IMAGES
of America

OCEAN BEACH

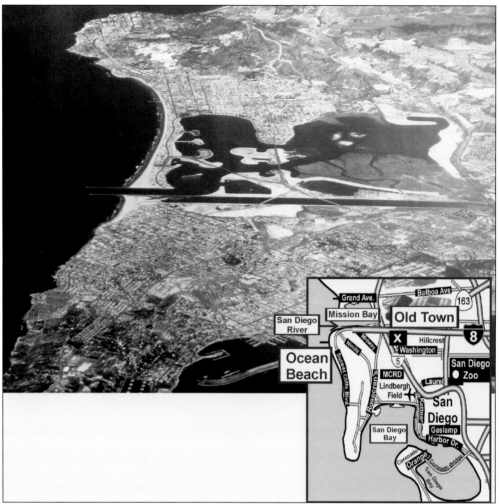

This 1950s photograph, taken before Interstates 5 and 8 were built, shows the proximity of Ocean Beach (south of peninsula) to Mission Bay Park, San Diego's aquatic playground, which was still under development at the time this view was captured. Ocean Beach, bounded by the Pacific Ocean on the west and the San Diego River on the north, is seven miles from downtown San Diego. Old Town, site of the first European settlement in California, lies due east. (Courtesy of the Ocean Beach Historical Society.)

ON THE COVER: Early Ocean Beach surfers return from the sea carrying their boards overhead. In the mid-1920s, surfing definitely was not for weaklings. One not only had to have the strength to get the heavy wooden board to the water, but also to control it once there. In the pre-balsa days (before 1932), boards were made of redwood, cedar, and other heavy woods, and could weigh as much as 100 pounds. (Courtesy of the Ocean Beach Historical Society.)

IMAGES
of America

OCEAN BEACH

The Ocean Beach Historical Society

ARCADIA
PUBLISHING

Published by Arcadia Publishing
Charleston, South Carolina

Printed in the United States of America

Library of Congress Control Number: 2013956286

For all general information, please contact Arcadia Publishing:
Telephone 843-853-2070
Fax 843-853-0044
E-mail sales@arcadiapublishing.com
For customer service and orders:
Toll-Free 1-888-313-2665

Visit us on the Internet at www.arcadiapublishing.com

This book is dedicated to Carol Bowers, founder of the Ocean Beach Historical Society, and to the memory of two local legends—Beach Town author Ruth Held (1906–1996), and historian Ned Titlow (1924–2011). They inspired us and made preserving history fun!

CONTENTS

ACKNOWLEDGMENTS

This project was a group effort of members of the Ocean Beach Historical Society (OBHS). Jonnie Wilson, the book's editor and primary writer, built on earlier work done by Kathy Blavatt, who selected, researched, and scanned most of the images used here. Others who assisted in the publication process include Susan James, who as project manager oversaw production and prepared the final page layout, and Barbara Busch, Jane Gawronski, Stephanie Greenwald, and Dedi Ridenour, who helped with photo selection, caption writing, final revisions, and anything else that was asked of them. Mary Allely, archivist of the Ocean Beach Historical Society, assisted with the location of photographs and other resources, as did volunteers Annie Marsch, Margaret Blue, and Heather Reed. We thank them all.

In addition to the treasure trove of materials available in the OBHS archives—newspapers, city directories, maps, and more—resources that were particularly helpful during the writing of this book include *Beach Town* by Ruth Held and *Ocean Beach: Continuity and Change in a Beach Community* (master's thesis) by James Christopher Carter.

Unless otherwise noted, all images appear courtesy of the Ocean Beach Historical Society. Special thanks go to photographer Steve Rowell, who not only donated photographs from his own collection, but also cheerfully completed "special assignments" as needed, with Jane Gawronski as his backup. The authors also wish to express their appreciation to Rick Crawford, supervisor of Special Collections at the San Diego Public Library, for reviewing the final draft of this book, and the dozens of people who donated their own historic photographs of Ocean Beach specifically for this project.

INTRODUCTION

It is easy to find Ocean Beach, a neighborhood of San Diego, California. Just travel west on Interstate 8 until it dead-ends at the Pacific Ocean and turn left. Once past the entryway sign, you'll find cute little beach cottages, a main street lined with palm trees, the longest concrete municipal fishing pier on the West Coast, rugged sandstone cliffs, tide pools, a surfing and bathing beach, and many happy people going about their day.

Although situated within the boundaries of a major city, Ocean Beach has the look and feel of a small beach town. Its main business district is only three blocks long, many of the stores are locally owned, and people out for a walk just about always bump into someone they know. Part of this small town feeling comes from being somewhat geographically isolated. Ocean Beach is hemmed in by the Pacific Ocean on the west, the San Diego River on the north, and the steep hills of Point Loma on the east. It is an out-of-the-way place that you do not pass through on your way to other parts of town. Arriving in Ocean Beach is intentional (unless you got in the wrong lane on the freeway).

Despite its seeming remoteness, Ocean Beach has long been a favorite spot to visit. The first to walk its beaches were the native Kumeyaay, who traveled there annually as part of their food gathering migration. (This particular beach was prized for its abundance of seafood.) With the arrival of colonizers and settlers—the Spanish in 1769 and the Americans in 1848—more people came to know Ocean Beach as a place of beauty and bounty that was ideal for a day trip. By the 1870s, it was a popular picnicking and camping spot for city folk, despite their having to endure a long wagon ride through mud flats to get there. It was close to both Old Town (site of the first European settlement in California in 1769) and New Town (downtown San Diego, founded in 1851).

It was not until the San Diego boom year of 1887 that William Carlson and Frank Higgins subdivided Ocean Beach and began selling lots so people could live, rather than camp, there. This was also the year that Ocean Beach got its name, having earlier been called Mussel Beds. The trend of the era was to develop beaches into seaside resorts, and in Ocean Beach, the streets were even given resort names such as Saratoga, Niagara, and Cape May. Carlson and Higgins took their vision a step further—they built a resort-style hotel (a mini Hotel del Coronado) overlooking the sea. Sales were brisk at first, but San Diego suffered an economic downturn in 1888, and building came to a standstill. Banks failed, properties were abandoned, and Ocean Beach went back to being primarily a day-trip destination. It remained sparsely populated until 1909, when D.C. Collier, whose real estate company owned most of northern Ocean Beach, brought in city water, improved roads, put in sidewalks, planted trees, and built a streetcar line to connect the beach with downtown San Diego. Within a year, Ocean Beach had 100 homes, although many of these were built as second homes or rental cottages. Gradually, new dwellings were more likely to be for middle-class year-round residents.

Many of the early businesses catered to tourists, and Ocean Beach became *the* place to go on weekends. Wonderland, Ocean Beach's amusement park, drew crowds of thousands to the beach during its short life span (1913–1915), and dance halls and indoor saltwater plunges attracted many others. In the mid-1920s, however, much of the tourism moved to Mission Beach, which by then had its own amusement park and was also connected to downtown by streetcar. Ocean Beach began the shift from a seasonal tourist town to a family-oriented community, and the focus changed to providing goods and services for residents, not visitors. A strong community spirit began to evolve, one that has survived to the present day.

Ocean Beach has maintained its historic beach-town look in large part due to the efforts of its citizens to revitalize, rather than redevelop, the community. While many commercial buildings built in the 1910s and 1920s remain in the business district, they have been repurposed to meet the needs and likes of today's residents. Electing a planning group, adopting a master plan, and passing a 30-foot height limit for buildings have helped to avoid dramatic change in Ocean Beach. Residents have taken an active role in the evolution of their community and are willing to work together to preserve its unique character, including its historic homes. Ocean Beach has eclectic architecture, but it is best known for its beach cottages, most of which were built prior to 1932. Many are preserved as part of the Ocean Beach Cottage Emerging Historical District, formed in 2000.

Residents of this relaxed and casual place refer to their community simply as "O.B." and call themselves "OBceans" (sometimes spelled "Obecians"). Words used by outsiders to describe Ocean Beach include laid-back, funky, quirky, and unique. Perhaps a popular license plate holder says it best: "Ocean Beach: An attitude, not an address." Helping to keep this sense of place strong are long-held Ocean Beach traditions, which include a Christmas parade, a kite festival in March, a street fair in June, and Fourth of July fireworks off the pier, all undertaken with a cohesive community spirit.

Visitors still flock to Ocean Beach, but few attractions have been created strictly for them. Mostly, they come to eat and play at the same places OBceans do. One of the main lures, of course, is the Pacific Ocean with its swimming and surfing opportunities. In 1923, a visitor to Ocean Beach wrote a poem about its many charms, which included these lines:

> Ocean Beach, the thought's alluring,
> When we're city heat enduring;
> Oh, to bathe where breakers high,
> Round and o'er us swish and fly,
> Then recede while on the sand,
> Breathless, dripping, cool we stand.

Although the bulk of this book focuses on the history of Ocean Beach through the 1940s, the story does not stop there. The final chapter presents trivia spanning all decades of Ocean Beach's evolution, giving a glimpse of the more recent history of this laid-back, funky, quirky, and unique community.

One

FROM MUSSEL BEDS
TO OCEAN BEACH

The first to experience the beauty and bounty of the area now known as Ocean Beach were the native Kumeyaay, who journeyed each spring from Cosoy, their village at the mouth of Mission Valley, to the pristine seashore to feast on its abundant seafood—mussels, clams, abalone, and more. This wealth of sea life led to an early American name for the area: Mussel Beds. The Spanish name was Los Médanos (The Dunes).

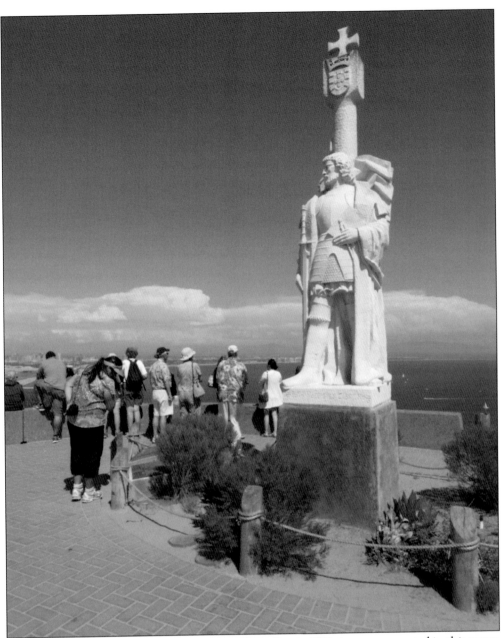

Juan Rodríguez Cabrillo, who discovered San Diego Bay in 1542, is commemorated in this statue at Cabrillo National Monument, located at the tip of Point Loma, a few miles south of Ocean Beach. Cabrillo did not stick around for long and neither did Sebastián Vizcaíno, who came in 1602, although Vizcaíno did send out a party of men to explore the Point Loma area. The person who established San Diego as the first permanent European settlement in California was Father Junípero Serra, a Spanish missionary who arrived in 1769 and founded mission San Diego de Alcalá on a hill overlooking San Diego Bay. The area at the foot of the hill grew into a community now known as Old Town. Which early resident of the mission or settlement first used the words Los Médanos to describe Ocean Beach is not known, but Los Médanos would have been the closest beach to Old Town, a straight shot west. (Courtesy of Steve Rowell.)

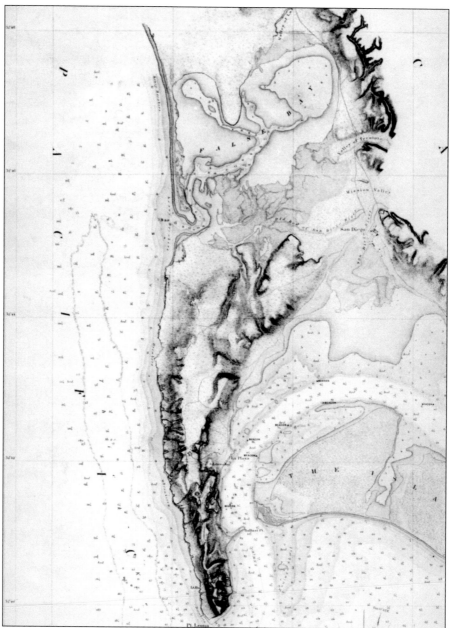

When this nautical chart was drawn in 1859, San Diego was under US rule and the area known today as Ocean Beach was an undeveloped and largely unpopulated landmass located just south of the entrance to False Bay (now Mission Bay). By the late 1850s, this beach had become a popular picnic spot for residents of Old Town and was commonly called Palmer's Place, in honor of the area's only year-round resident. Palmer made his living selling well water to visitors who needed to refresh their horses for the long trip home. The biggest event at Palmer's Place took place on July 4, 1872, when 200 people from Old Town, virtually the entire community, traveled west to the beach, lured by the promise of free mussels—roasted, fried, or boiled. With no overnight accommodations (unless one brought camping gear), Ocean Beach remained primarily a day-trip destination for several more decades.

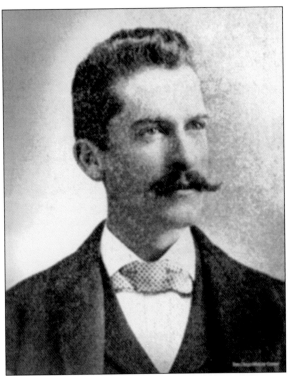

The first large-scale attempt to develop the beach into a town came in early 1887 when 23-year-old William H. "Billy" Carlson and his partner, 26-year-old Frank J. Higgins, bought a 600-acre tract of empty land for $50,000, subdivided it, and officially named the area Ocean Beach. Carlson then began selling lots—lots of lots—some 2,200 in the first few weeks.

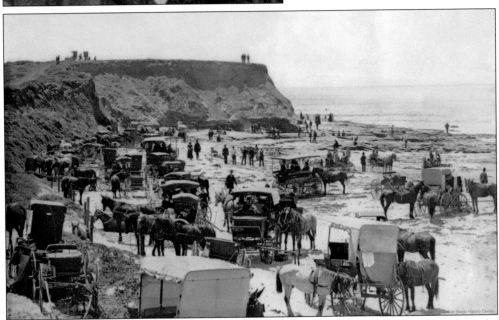

Prospective landowners arrived by horse and buggy, the only way to get to Ocean Beach at the time, although Carlson and Higgins promised that a train to the new subdivision would be built soon. However, construction of the Ocean Beach Railroad was plagued with problems, and the line only operated for a few months before folding in late 1888. These buggies are congregated in the area now dominated by the Ocean Beach Municipal Pier, built in 1966. (Courtesy of San Diego History Center.)

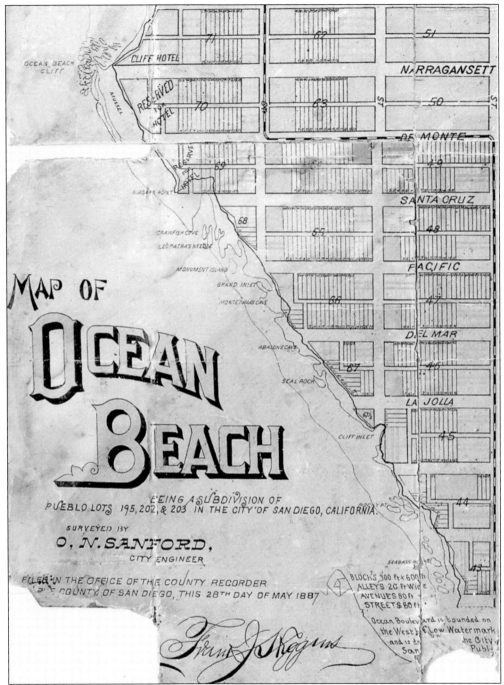

On May 28, 1887, Carlson and Higgins filed this subdivision map of Ocean Beach with the county recorder. The map not only shows street names, but also the future site of the Cliff House hotel, the proposed route of the Ocean Beach Railroad (dashed line), and the names of beaches and cliff formations. Many of the east–west streets were named after well-known resorts, such as Niagara, Saratoga, and Narragansett, perhaps to give status to the new community and to lure wealthy buyers.

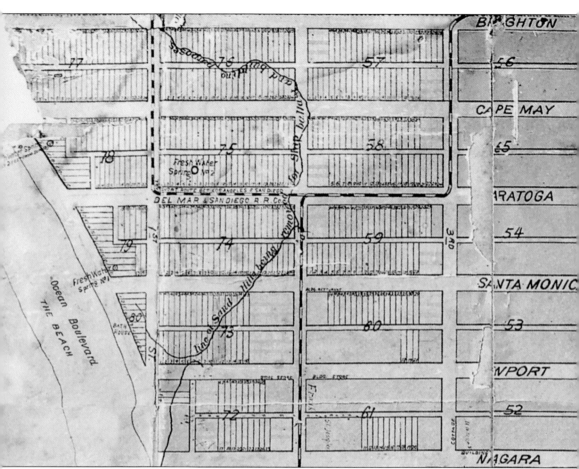

The northern section of the subdivision map shows Ocean Beach's sand dunes (marked by the irregular line between Brighton and Newport Avenues). The numbered streets (First through Seventh) did not become Abbott through Guizot Streets until 1900. The locations of several fresh water springs essential to the development of the new community are also marked. In the early days, corrals and stables were located near these springs so horses could be watered and fed.

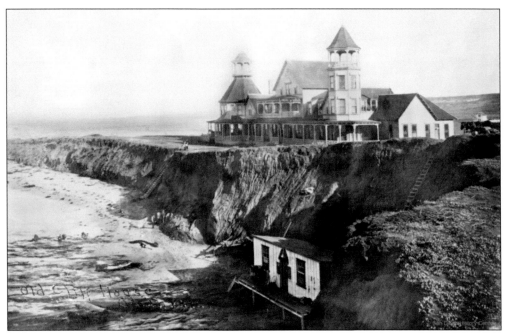

The Cliff House was the culmination of another promise made by land developer Billy Carlson. Opened on January 1, 1888, the ornate $18,500 hotel featured rooms on two levels. The shack at the foot of the cliffs (near Narragansett Avenue) was owned by Capt. Abraham Thomas, an early year-round resident and iconic figure of Ocean Beach. Thomas, like his predecessor Palmer, catered to travelers by watering their horses (25¢ a head), serving home-cooked meals, and renting bathing suits and fishing poles. He lived a long and productive life, passing away in 1913 at age 94. (Courtesy of San Diego History Center.)

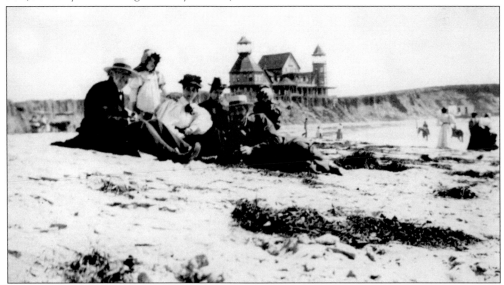

Carlson sold the Cliff House in January 1889, and it was later renamed the Ocean Beach Hotel. Unfortunately, this was a short-lived venture. The elaborate building burned to the ground in December 1898 when a hanging lamp fell to the floor and exploded. At the time of its destruction, room and board at the hotel was $1.50 per night.

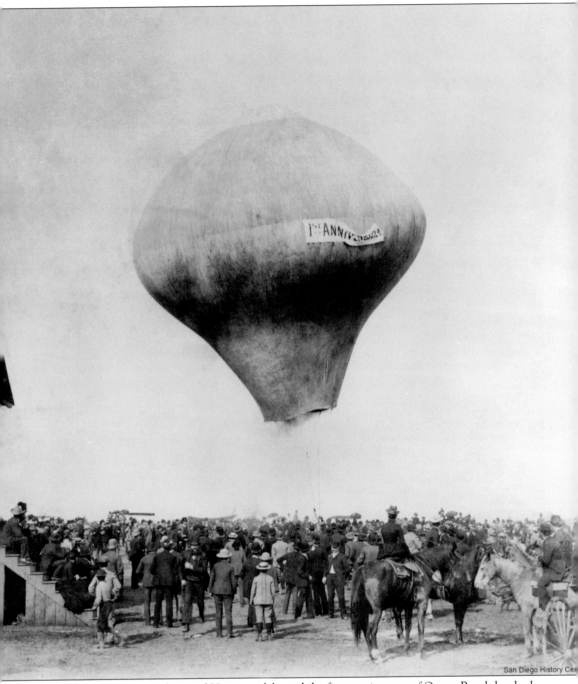

On April 15, 1888, Carlson and Higgins celebrated the first anniversary of Ocean Beach land sales with a hot air balloon ascension. Unfortunately, about this same time, San Diego's boom collapsed, and the area slid into an economic slump. Hopes for the development of Ocean Beach quickly faded away. Frank J. Higgins committed suicide in January 1889, but Billy Carlson channeled his energies into a new field—politics. On April 5, 1893, at age 28, he was elected mayor of San Diego, the youngest person ever to hold that office. (Courtesy of San Diego History Center.)

At the time of this 1902 real estate excursion, only a handful of homes had been built in Ocean Beach. These prospective buyers are standing near Ocean Beach's famous sand dunes, which ran from Brighton Avenue to Newport Avenue between Bacon and Abbott Streets.

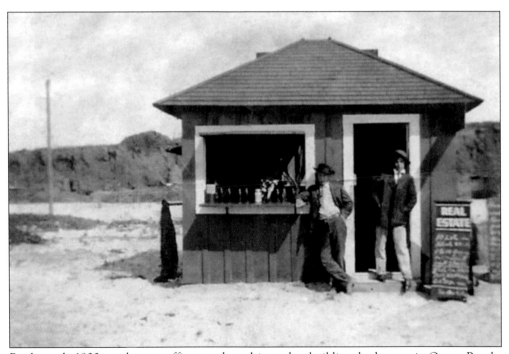

By the early 1900s, real estate offices, such as this modest building, had set up in Ocean Beach.

Ocean Beach pioneer John Moffett picnicked and camped at the seashore for many years prior to making it his home. Arriving in San Diego in 1872, he soon fell under the spell of Ocean Beach. By the 1880s, he and his family were making regular buggy trips to the beach to fish, swim, hunt for shells, and enjoy clambakes. Finally, in 1907, John and his wife, Julia (Mumford), along with their daughter, Dot, became some of the first year-round residents of the beach when they moved into their new home at 4651 Niagara Avenue. (Courtesy of San Diego History Center.)

Frank "Mac" McElwee, another pioneer, arrived in 1905 after being told by a Virginia doctor that he had terminal tuberculosis. Seeking a place near the water where there was "absolutely nothing going on," McElwee was directed to Ocean Beach. There, Captain Thomas rented him a tent frame and space near his windmill, an arrangement that cost the young man $2.50 a month, but included all the fresh water he could drink. McElwee regained his health, went into the real estate business, and helped develop the beach area he had grown to love.

Two

THE D.C. COLLIER YEARS

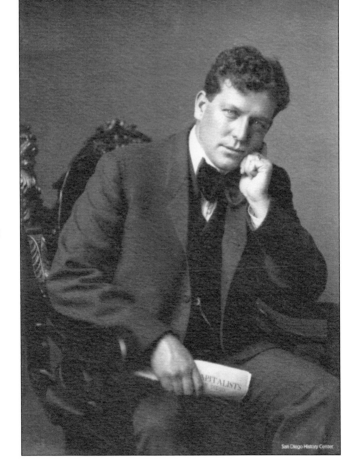

In 1907, David Charles (D.C.) Collier—attorney, real estate promoter, and civic leader—began to promote undeveloped Ocean Beach. Within a two-year period, Collier transformed a seaside outpost with only a handful of year-round residents into a thriving community connected to the rest of San Diego by a modern streetcar line. For this achievement, he has often been called "The True Father of Ocean Beach." (Courtesy of San Diego History Center.)

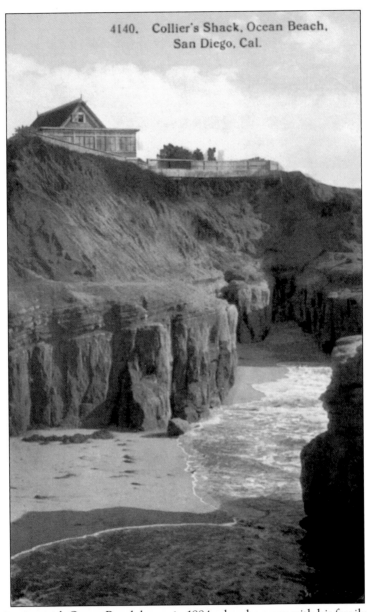

4140. Collier's Shack, Ocean Beach, San Diego, Cal.

Collier's fascination with Ocean Beach began in 1884, when he came with his family to San Diego and quickly fell in love with Ocean Beach's picturesque rock formations and cliffs. In 1887, the Colliers bought a lot from Billy Carlson, and 16-year-old D.C., then known as Charlie, set about building a beach house on the bluff at the end of Coronado Avenue. Over the years, his simple dwelling, called "Collier's Shack," was transformed into a substantial home complete with one of San Diego's first swimming pools. D.C. and his wife, Ella May (Copley), lived there year-round during Ocean Beach's formative years. Collier left San Diego for Chicago in 1918; the following year, a Midwestern family purchased his spacious dwelling and converted it into the Alligator Rock Lodge and Tea Room. This fancy establishment featured a glassed-in porch overlooking the Pacific, six furnished rooms, hot baths, an open-air plunge, and a restaurant that served breakfast, lunch, afternoon tea, and dinner. The lodge was advertised as "a quiet retreat" for "nice people who are tired of noisy lobbies, cabarets, and jazz bands."

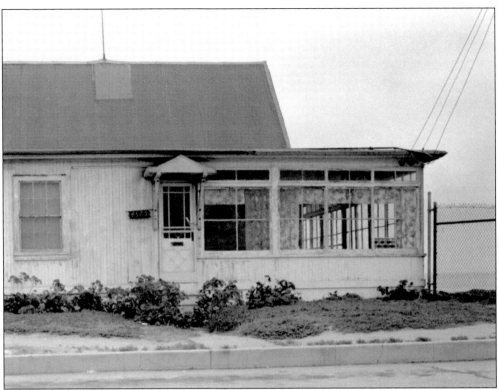

Alligator Rock Lodge continued as an inn until the early 1930s and then spent several decades out of the limelight. This 1969 photograph was one of the last taken of the building before it was demolished. A fourplex condominium project now stands on this site at the end of Coronado Avenue. (Courtesy of Steve Rowell.)

This view of sparsely populated Ocean Beach was taken from the cliff near Collier's Shack, looking north. The unpaved road stretching across the center is Bacon Street. The ice plant in the foreground, although common in California, is not native. Originating in South Africa, it may have been introduced to the Pacific coast as early as the 1500s, arriving in sand used as ship's ballast.

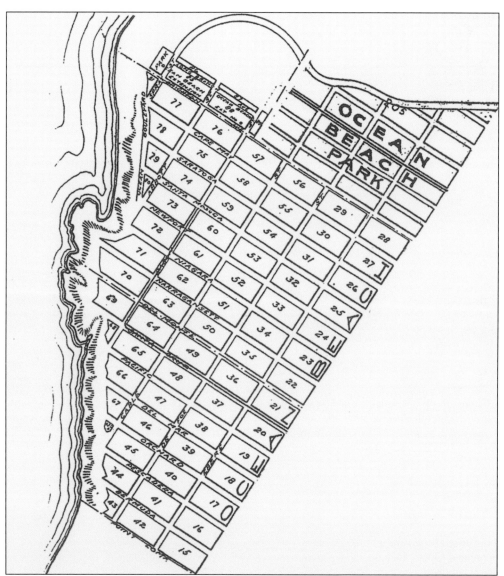

In 1907, as president of Ralston Realty, D.C. Collier oversaw the purchase of a large tract of land in the northern part of Ocean Beach. This area, called Ocean Beach Park (upper right), was bounded by Brighton Avenue on the south, Froude Street on the east, and the ocean and bay on the west and north. Between 1907 and 1909, Collier improved his property by leveling the lots, providing city water, grading the streets, putting in curbs and sidewalks, and planting ornamental trees. When he advertised his subdivision as the "Nob Hill District" of Ocean Beach, prospective residents began snapping up lots for as little as $225 ($45 down and $12 a month). In 1909, Collier reorganized and began doing business as D.C. Collier and Company, with three sales offices in Ocean Beach and one downtown. By the end of the year, more than 100 homes had been built in the San Diego neighborhood of Ocean Beach.

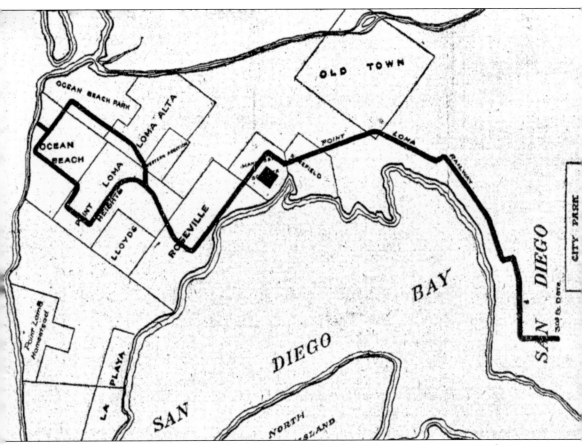

D.C. Collier's most important contribution to Ocean Beach was bringing in a streetcar line to connect the fledgling community to downtown San Diego. Its seven-mile route is indicated by the solid black line on this map. Collier secured the franchise for this venture and was president of the Point Loma Railroad throughout the building of the line (1908–1909). This was an important development, as having a reliable form of transportation made it possible for people to work downtown and live in Ocean Beach. Following the line's dedication on May 1, 1909, it was turned over to the San Diego Electric Railway Company, owned and operated by John D. Spreckels. During the time Collier was making Ocean Beach a livable place, he was also busy developing other parts of San Diego, including University Heights, Normal Heights, North Park, Encanto, and Point Loma, just up the hill from Ocean Beach. In 1907, two of Collier's companies, Ralston Realty and the Point Loma Syndicate, owned 900 acres of land between Ocean Beach and Roseville.

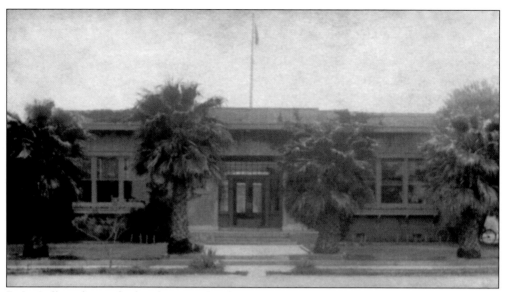

D.C. Collier also pushed to have a schoolhouse built for the children of Ocean Beach. On December 15, 1909, a two-room stucco school for grades one through eight was dedicated on the corner of Santa Monica Avenue and Defoe Street (now Sunset Cliffs Boulevard). The architect for the $5,000 building was William S. Hebbard, who four years earlier had designed the Marston House in Balboa Park with his then-partner Irving Gill.

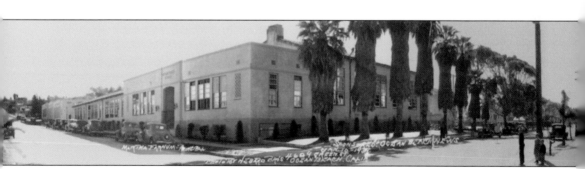

The original two-room Ocean Beach School was replaced in 1935 with a modern earthquake-proof building at a cost of $40,000. Among the special features of the Spanish-style school were beautiful tiled entryways, a 360-seat auditorium, and a heating system that kept the entire facility warm on chilly days. Some eight decades later, the school still serves the children of Ocean Beach.

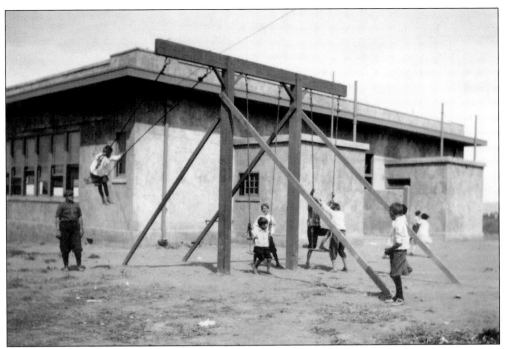

In 1909, Ocean Beach Elementary was a swinging place! Even though the play yard was pretty basic, students were happy they no longer had to travel to Roseville or downtown.

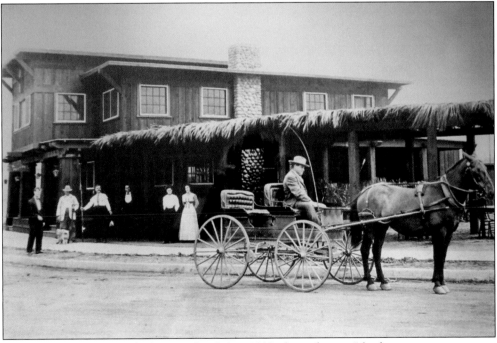

Ads for the Pelican Inn, which opened on July 4, 1909, claimed it was "the finest restaurant on any beach near San Diego." Located at West Point Loma Boulevard and Abbott Street, the eatery's specialty was fish dinners. In 1913, it changed its name to the Sunset Inn and was well known for many years for its music and entertainment, as well as its tasty meals.

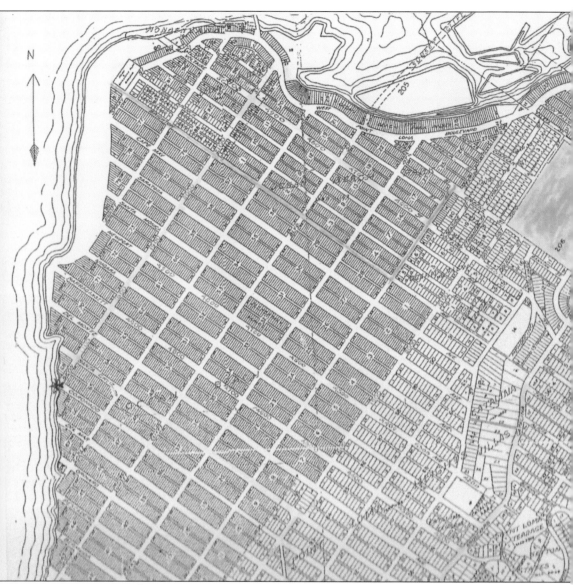

In 1909, D.C. Collier petitioned the City of San Diego to establish a 60-acre park in the eastern portion of Ocean Beach (center right). The city agreed after Collier promised to not only pay for the landscaping, but to build a road through the park as well. Appropriately, the site was named Collier Park in his honor. Unfortunately, the city failed to develop the land, and as the years went by, its link to Collier was forgotten. In 1915, the Door of Hope, a facility for unwed mothers, was built on parkland and remained there until 1962, when it relocated to Kearny Mesa. Collier Junior High School, built within the confines of the park in 1959, is still there, but it was renamed Correia Middle School in 1984. Also located on the original 60 acres of parkland are Bill Cleator Community Park (15 acres), a church, several large apartment complexes, the Ocean Beach Community Garden, the Pt. Loma Native Plant Garden, and a small patch of land at Greene and Soto Streets that still bears the name Collier Park.

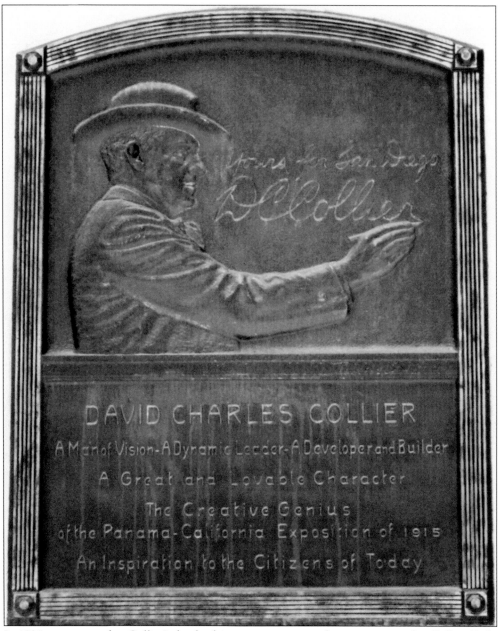

DAVID CHARLES COLLIER
A Man of Vision - A Dynamic Leader - A Developer and Builder
A Great and Lovable Character
The Creative Genius
of the Panama-California Exposition of 1915
An Inspiration to the Citizens of Today

In 1936, two years after Collier's death, this commemorative plaque was erected in Balboa Park. The plaque was appropriately placed, as D.C. Collier had been pivotal in the park's development. At the same time he was building Ocean Beach, Collier had served as director-general (and later president) of the Panama-California Exposition, a world's fair that was held in Balboa Park in 1915–1916. During his six years in these positions, Collier served without pay, gave $500,000 of his own money to the exposition, and paid his own travel expenses while promoting the fair across the country. By March 1914, burdened by debt, he found it necessary to resign as president, just months before the fair opened to the world. When he died in 1934, Collier was on the verge of bankruptcy. His obituary described him as the "man who gave most, who achieved most, and who received least among all of the builders of San Diego."

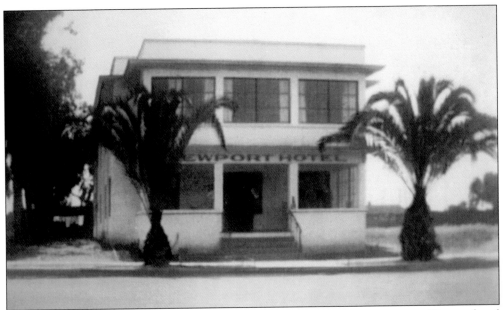

In 1909, a few months after the debut of the Ocean Beach streetcar line, a two-story, 20-room hotel opened for business on Newport Avenue between Cable and Bacon Streets. Originally known as The Pearl, its name was changed to the Newport Hotel (as shown here) in 1914 to better reflect its location on Ocean Beach's main street.

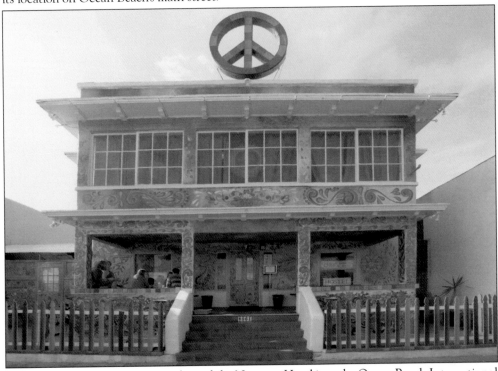

In 1995, a major refurbishing transformed the Newport Hotel into the Ocean Beach International Hostel, providing travelers from around the world the chance to experience a quintessential beach town. (Courtesy of Steve Rowell.)

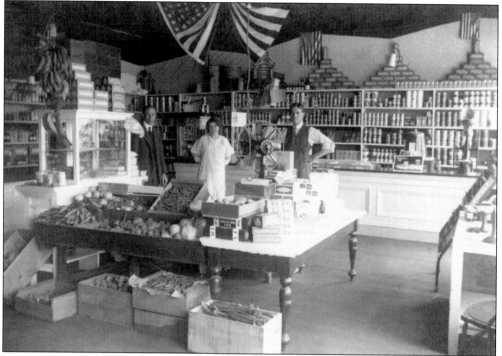

When early residents needed fresh foods, the Ocean Beach Grocery was there to help and even offered free delivery. Opening in 1913 in the 5000 block of Newport Avenue, the store was owned and operated by Guido Faber and his wife, Christine. By 1923, the Fabers owned three grocery stores in Ocean Beach—two on Newport Avenue and one on Bacon Street.

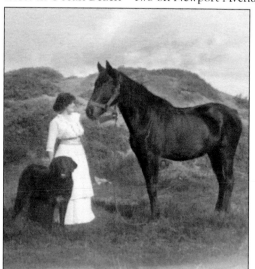
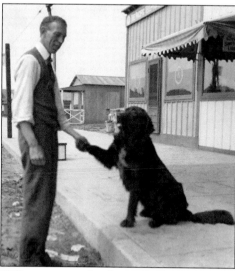

Christine Faber (left) enjoyed outings to Sunset Cliffs to exercise her horse Dolly and her dog Carlos. In 1913, horses were still a common sight in Ocean Beach and several local businesses, including the Fabers' grocery store, used horse-drawn wagons to deliver their goods. Not much was happening on unpaved Newport Avenue when the photograph on the right was snapped of grocer Guido Faber and Carlos making a gentlemen's agreement. (Perhaps over dog biscuits in the family store?)

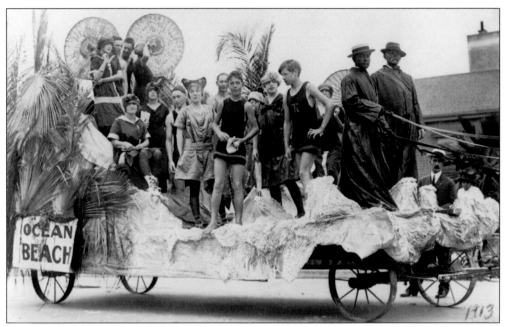

In 1913, Ocean Beach—now beginning to have an identity of its own—entered this horse-drawn float in a downtown San Diego parade. Not much is known about the theme of the event or the occasion, but it may have been connected to the September 25 citywide celebration of Balboa Day, during which floats and marching units paraded down C Street.

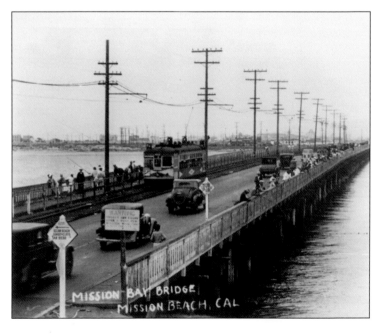

In 1915, the Bayshore Railway Company erected a 1,500-foot wooden bridge connecting Ocean Beach with undeveloped Mission Beach. The 50-foot-wide structure at the foot of Bacon Street could be crossed by walking, driving, or taking a trolley. It was also a great place to stop and fish, and old-timers were saddened when the structure was torn down in January 1951. (Courtesy of San Diego History Center.)

Three

WONDERLAND

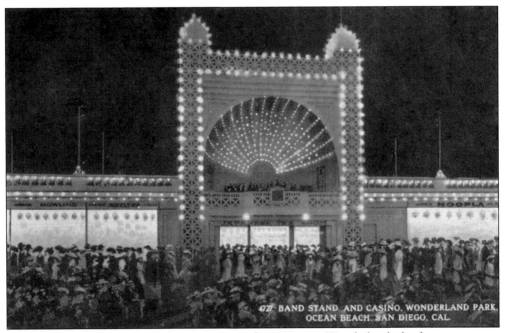

Ocean Beach's biggest construction project in the 1910s was Wonderland, the first amusement park to be built in San Diego. This $300,000 tourist attraction, which occupied eight acres at Voltaire and Abbott Streets, drew a crowd of 35,000 when it opened on July 4, 1913. At the Casino (pictured), the park's spacious restaurant, diners could pick from "1000 epicurean delights" prepared by a half dozen chefs, several of whom were imported from New York.

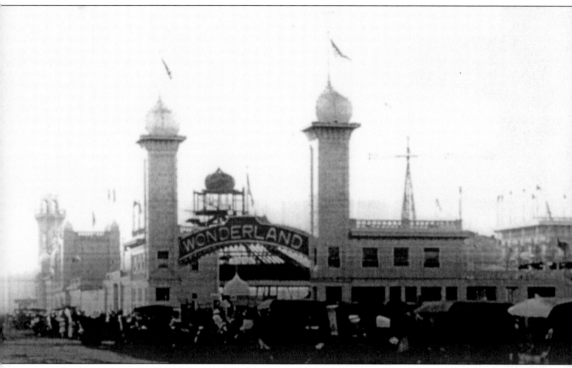

Wonderland—with its 16 fanciful buildings and 40 rides and attractions, including the largest roller coaster on the West Coast—was built in a record four months by the Ocean Bay Beach Company, owned by Wilson Chamberlain, H.C. Snow, and E.C. Hickman. It took more than 500 steelworkers, carpenters, masons, machinists, and other laborers working day and night to complete the project on schedule. Adjoining the modern facility was a large parking lot for those who would be arriving at the amusement park by car. On opening day, the number of vehicles traveling down from Los Angeles (300) was equal to the entire population of Ocean Beach at the time. A year earlier, in 1912, Wonderland's architect Robert H. Orr had designed San Diego's First Presbyterian Church downtown. Apparently, Wonderland was his only flight of fancy, as his later projects were almost exclusively churches and educational institutions.

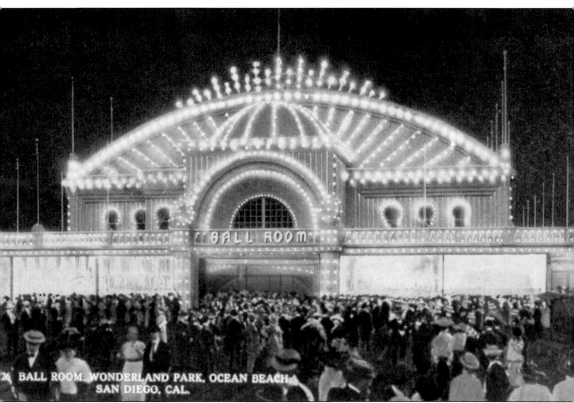

26 BALL ROOM, WONDERLAND PARK, OCEAN BEACH, SAN DIEGO, CAL.

At night, when the switches were flipped, 22,000 tungsten lights came on, turning Wonderland into the Las Vegas of its day. The park's Waldorf Ballroom (pictured) boasted a 20-piece orchestra and a solid maple floor and could accommodate 800 dancers at a time. There were strict rules to be observed on the dance floor, however. Women had to wear hats, and turkey trotting, bunny hugging, and ragtime—the "dirty dancing" of that era—were strictly forbidden.

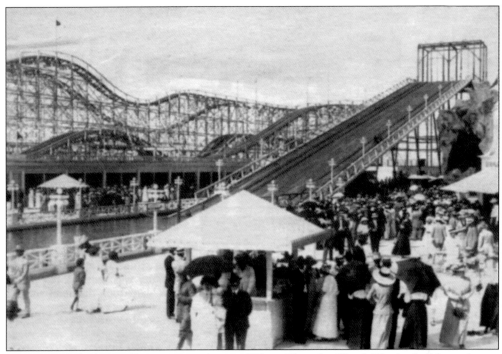

Wonderland's $65,000 roller coaster, nicknamed "Race Thru the Clouds," had a double track over which two cars raced each other for a distance of one and three-eighths miles. Reportedly, the car with the heftiest riders had a distinct advantage.

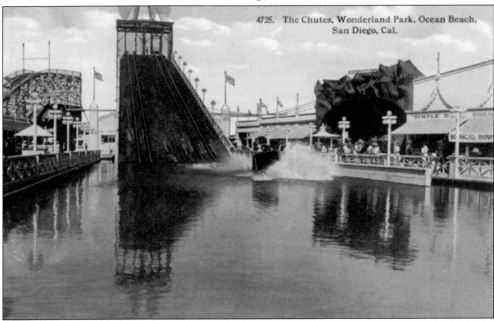

The "Shoot the Chutes" ride was second in popularity to Wonderland's roller coaster. Thrill seekers got their adrenaline going as they traveled rapidly by flat-bottomed boat down the chute, ending with a big splash in the lagoon at the bottom. According to one newspaper reporter, "The first impulse after landing is to do it again . . . it far surpasses tobogganing in delight."

This lion was just one of hundreds of exotic animals on display at Wonderland. On opening day, the park's menagerie boasted 350 monkeys—including Mr. Spider, said to be the oldest monkey in captivity—five lions, a hyena, two California mountain lions, a puma, two leopards, three wolves, a coyote, two raccoons, a California bobcat, and two black bears. The animals had previously been exhibited at Luna Park, a Los Angeles amusement park that went out of business in 1912.

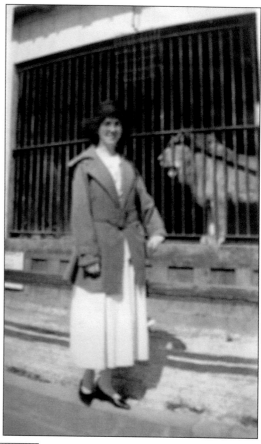

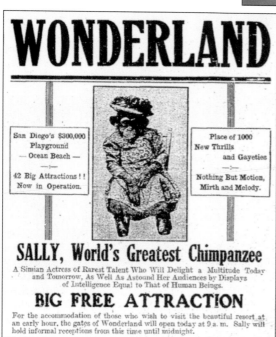

WONDERLAND

San Diego's $300,000
Playground
— Ocean Beach —

42 Big Attractions!!
Now in Operation.

Place of 1000
New Thrills
and Gayeties

Nothing But Motion,
Mirth and Melody.

SALLY, World's Greatest Chimpanzee

A Simian Actress of Rarest Talent Who Will Delight a Multitude Today
and Tomorrow, As Well As Astound Her Audiences by Displays
of Intelligence Equal to That of Human Beings.

BIG FREE ATTRACTION

For the accommodation of those who wish to visit the beautiful resort at
an early hour, the gates of Wonderland will open today at 9 a. m. Sally will
hold informal receptions from this time until midnight.

Some of the animals had special talents, such as "Sally, World's Greatest Chimpanzee," who was not only one of Wonderland's most popular acts, but undoubtedly the best-dressed monkey in town (although it is not known if her shoes and hat matched her dress). Another animal star was Arabia, a $25,000 "equine actor" who jumped through a burning window in an act called "Fighting the Flames."

SUNDAY AT

WONDERLAND

San Diego's $300,000 Playground
—— OCEAN BAY BEACH ——

WILD ANIMAL CIRCUS

Carlos Bernardo, Famous South African Hunter and Trainer,
and His Group of

ACROBATIC NATURAL ENEMIES

Every Afternoon and Evening----Big Free Attraction

——SPECIAL FOR SATURDAY——

Wedding Among the Wild Beasts

Marriage Ceremony Will Be Performed in Steel Arena With
All Participants Surrounded by Ferocious
Jungle-Bred Creatures

CASINO BEAUTIFUL

PLACE OF 1000 EPICUREAN DELIGHTS

RATHSKELLER QUARTET—Lacey, Travares, Butler, Judson

NELLIE MONTGOMERY—Operatic Soprano

FREE TO ALL PATRONS

Doors of Casino on Voltaire Street Always Open to Diners.

Despite its 40 rides and attractions, Wonderland—the Coney Island of the West—only lasted for two years. In March 1915, just two months after the opening of the Panama-California Exposition in Balboa Park, Wonderland was sold at auction. The exposition, which had its own lively fun zone, had by this time become San Diego's premier tourist attraction, and consequently business at Wonderland took a big hit. D.C. Collier's newly formed Mission Bay Corporation took over most of the park's holdings, including the zoo animals. (Although the amusement park was situated on land that abutted Collier's development in Ocean Beach Park, Collier had not been a partner in the Ocean Bay Beach Company, builder of Wonderland.) The animals, Wonderland's most valuable asset, were put on display in Balboa Park. After the exposition closed on January 1, 1917, Collier oversaw the sale of the entire menagerie to the City of San Diego for the paltry sum of $500. In 1922, the animals became the nucleus for the new San Diego Zoo.

Four

EARLY OCEAN BEACH HOMES

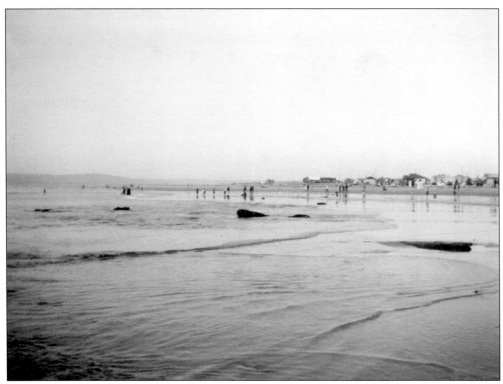

Many early property owners built their homes right on the beach, often just above the high-water mark. This often proved disastrous, as dozens of such dwellings were damaged, and sometimes destroyed, by raging winter storms and roaring tides.

Ocean Beach pioneer Joseph Hilliard chose to live high above the roaring tides. The substantial two-story home he built in 1894 still stands at the top of Brighton Avenue. The young farmer and his wife, Martha, raised chickens and bees and grew lemons in an orchard they called Sunset Grove. Restored by the current owners, it is now listed as a historic property.

In the 1920s, Ocean Beach pioneer Frank McElwee and his family settled near the Hilliards on the corner of Brighton Avenue and Venice Street. In the right photograph, taken from the McElwee house looking east toward Voltaire Street, Point Loma High School can be seen on the horizon. The school was built in 1925 to serve secondary students from Ocean Beach and throughout the peninsula.

This house in the 4700 block of Niagara Avenue was built by the John C. Clarke family on a double-size lot around 1907. It originally had a well in back to supply water to the household, but that remnant of yesterday was long ago boarded up. What does remain is another feature that dates back to Ocean Beach's early days: a century-old wisteria vine that canopies the left side-yard and front porch.

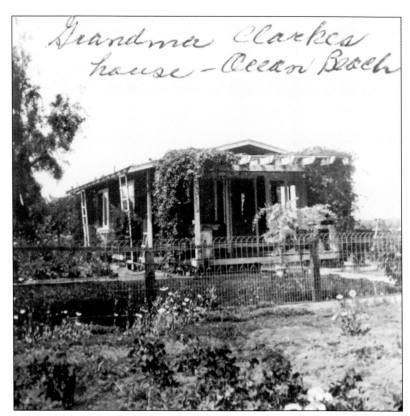

In the 1950s, historian and longtime OBcean Ned Titlow purchased the Clarke home and lived in it while his children were young, and then again after retirement. Each spring, from 2003 until his death in 2011, Ned hosted the popular Ocean Beach Historical Society's Annual Wisteria Garden Party, timing the event to when the purple-flowered vine would be in peak bloom, usually mid-March.

This early real estate ad lured buyers to Ocean Beach with the prospect that they would "double their money in the next few months." Many early speculators built rental cottages or summer homes on their newly acquired lots, but more and more landowners gradually began to live year-round in Ocean Beach.

Real estate agent Jean Rittenhouse was a New York artist before moving to San Diego and starting a second career in real estate. (The young woman had been ordered by her doctor to "go west" for her health.) Initially hired by developer D.C. Collier, she soon took off on her own and within 18 months was herself the owner of $40,000 worth of Ocean Beach lots. She was living proof of her ad, which claimed: "Lots here are the best investment in San Diego today."

This 1911 home, designed by an unknown architect in the style of Irving Gill, is unusual for the beach area. Erected on the corner of Seaside and Castelar Streets, the structure's slightly bowed Doric columns, cement work, lack of eaves, and other design elements are reminiscent of the work of Gill. Most likely, it was the project of one of his students.

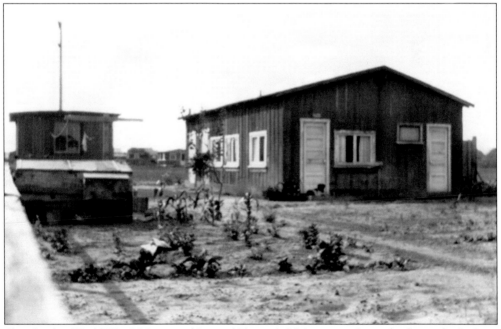

Shortly after World War I, Henry and Lottie (Oleman) O'Mara moved into this house, built about 1909 in the 4800 block of Cape May Avenue. Driftwood was used in the construction of the single-wall dwelling, one of the earliest homes to be built in central Ocean Beach. The O'Maras had no electricity, and the only running water was outside the house.

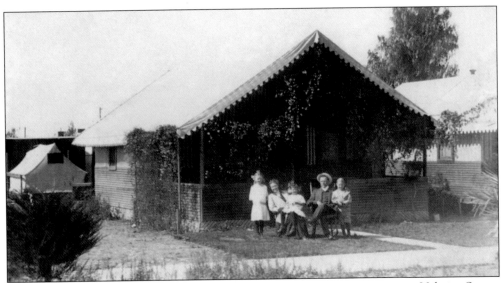

In 1912, Ruth (Shepherd) Vallin lived with her family in this tent cottage on Voltaire Street. Tent cottages, which typically had a canvas roof, were popular at that time for vacation homes, but some people purchased them for permanent residences, usually replacing the canvas roof with a solid one at some point.

A Cozy Little Home for Beach or Mountain

YOUNG'S SLIP-TOGETHER BUNGALOWS

A portable bungalow, light, roomy and quickly put together. Sanitary, durable and delightful. Comfortable all the year 'round in Southern California. To sleep in one of these houses is a joy forever. If you have a vacant lot at the Beach or in San Diego, you should have one.

Delivered and erected in and around San Diego for $69.00 and up.

Write for particulars or call and see them. Young's Slip-Together Bungalows demonstrated at Ocean Beach.

NEWPORT AVENUE, NEAR THE BEACH

OPEN ON SUNDAY

Another vacation option was the slip-together home, offered for as little as $69 assembled. In 1913, Ocean Beach had a showroom to convince people this was the way to go, but little is known about the success of this venture.

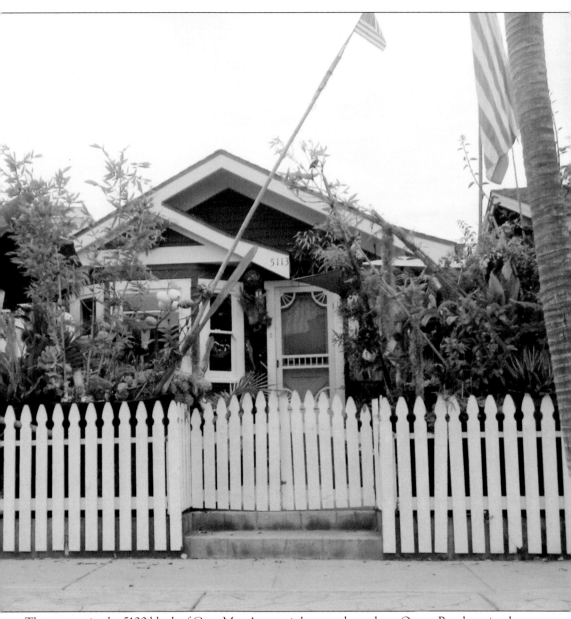

The cottage in the 5100 block of Cape May Avenue is known throughout Ocean Beach as simply "The Red House." Built around 1911, its early years were quiet and unremarkable. But then, during the early 1970s, the house became a gathering spot for young activists moving into the area, and, as a result, often turned up in the news. The underground newspaper *Ocean Beach People's Rag* was published there, the O.B. People's Food Co-op distributed food from its garage, and at one time, the house was used as a drug-counseling center. The current owners bought the cottage in 1998 through real estate agent Priscilla McCoy, an Ocean Beach Historical Society board member who was instrumental in forming the Ocean Beach Cottage Emerging Historical District. And as they say, the rest is history. In 2002, the house on Cape May Avenue, by then over 90 years old, was designated a historic cottage.

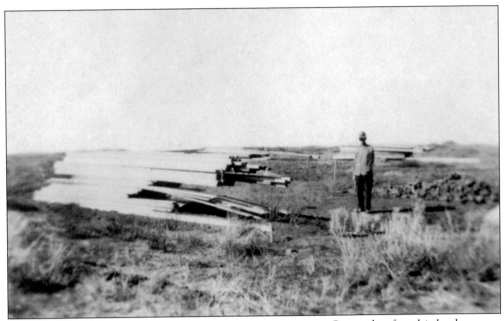

Six weeks after this load
of lumber was delivered in
December 1911, a new two-story
home at 4905 Del Mar Avenue
was ready for occupancy by
the Martin Mulville family.

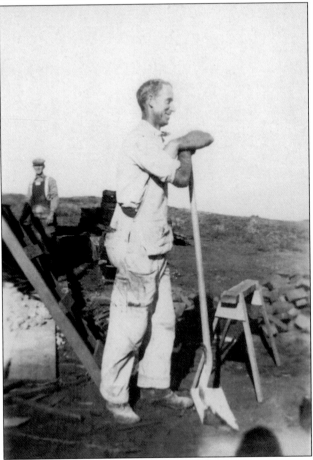

Creating a home out of the
pile of lumber was the job
of this man, Mr. Stillwell,
foreman of the construction
project. During restoration
a century later, contractors
raved about the quality of
craftsmanship in the home.

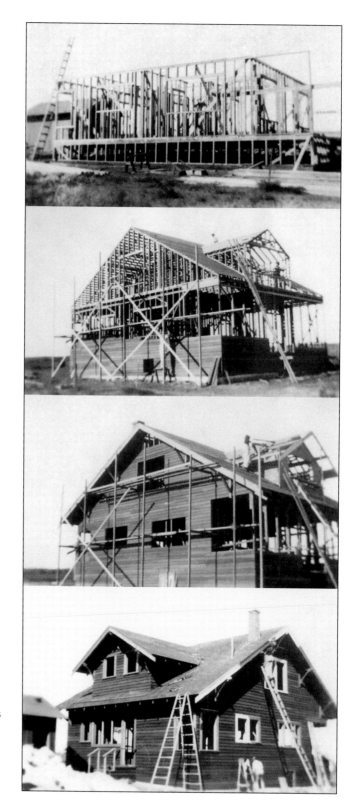

Unusual for the time, the Mulvilles kept a weekly photo record of the building of their Del Mar Avenue home. These four images show stages of construction, from the building's framing in early December 1911 (top) to its completion six weeks later in January 1912 (bottom).

45

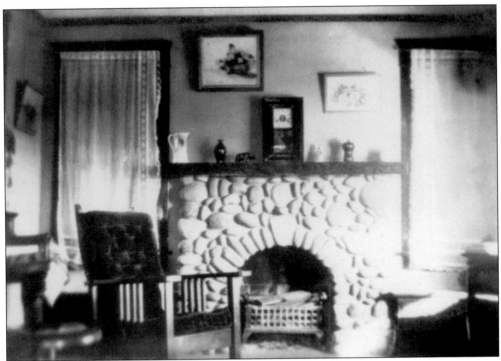

The stone facade on the Mulvilles' fireplace was a popular style at the time. Although the source of the building materials is unknown, stones such as these were readily available at nearby Sunset Cliffs.

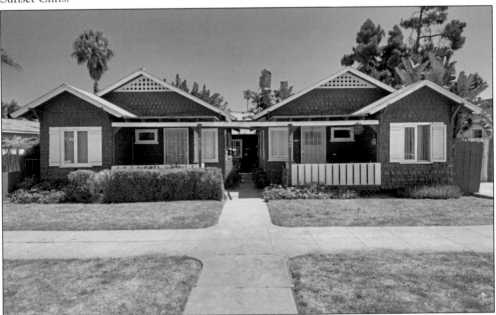

These 1914 cottages in the 4900 block of Narragansett Avenue are typical of the single-wall homes being built at that time. Single-wall construction was all that was needed in Ocean Beach's year-round temperate climate, meaning the homes could be built very economically. Many of these early homes are still standing after nearly a century of use, more often than not as rentals.

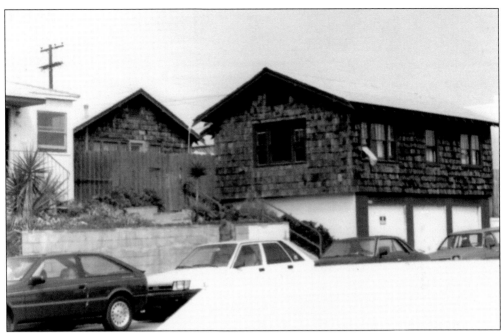

The Rankin house on Santa Monica Avenue (above) and the side-by-side buildings on Abbott Street (below), are elevated because they were built long ago on Ocean Beach's famous sand dunes. Later, retaining walls and ground-level rooms (garages, in one case) were added to stabilize the structures. John Rankin built his house around 1915 but lived with his family on West Point Loma Avenue most of his years in Ocean Beach. His daughter, Margaret Rankin, who served as Ocean Beach's librarian for almost four decades, lived in the dune cottage toward the end of her life. The Abbott Street buildings were used as a real estate office before becoming private dwellings.

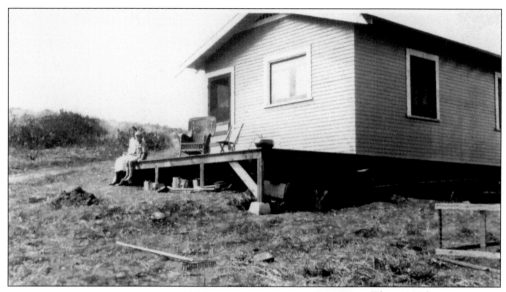

This 1924 home was one of the earliest to be built on the Niagara Avenue hill.

Members of the Turskey family stand in front of the house they purchased in the 5000 block of Muir Avenue when the street was still unpaved.

Stone masonry, as shown in the front porch pillars of this Ocean Beach home, was popular from the 1910s through the 1930s. Stones were also used in walls, fireplaces (such as the Mulvilles'), and decorative additions. This house is on the corner of Newport Avenue and Ebers Street.

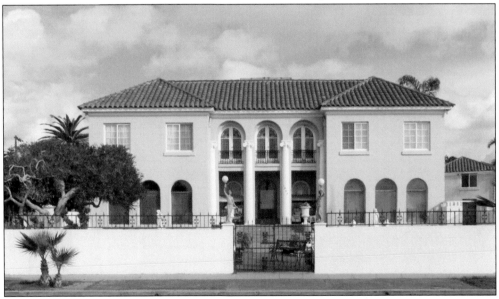

This 1927 palatial home on Sunset Cliffs Boulevard was built by real estate promoter John P. Mills, who, along with Jesse Shreve and Alexander Pantages, developed the Sunset Cliffs area. The upscale subdivision, which encompassed several cliff-side blocks south of Point Loma Avenue, had very restrictive covenants that specified that only expensive Spanish Revival–style villas could be built on the lots. Ironically, Mills's $75,000 home—built as a model to inspire other property owners—was constructed in the Italian Renaissance style (although it did meet the requirement of a red tile roof). Because the Great Depression hit shortly after the subdivision opened, fewer than a dozen homes were built in the early years. Mills's home, known as the "Pink Mansion," caused quite a stir in its day. Its special features included a four-car garage, solarium, billiard room, and outdoor amenities such as a swimming pool and tennis courts. (Courtesy of Steve Rowell.)

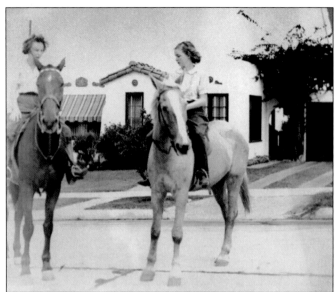

Marie Quist and an unidentified friend pose on their horses in front of Marie's Spanish-style Cape May Avenue home, built around 1929. These smaller versions of the villas promoted by John P. Mills and associates were popular in the Ocean Beach area. Marie's horse, King John, was kept in a stable on Catalina Boulevard.

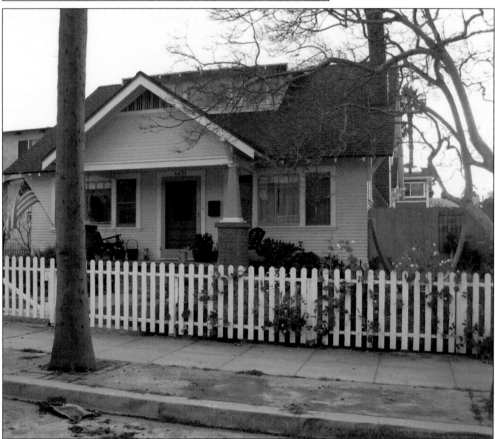

This home on Larkspur Street is a Craftsman, a popular architectural style in Ocean Beach. It was restored in 2007 by then-owners architect Charles Roberts and his wife, Karen, and was designated historic under the Ocean Beach Cottage Emerging Historical District.

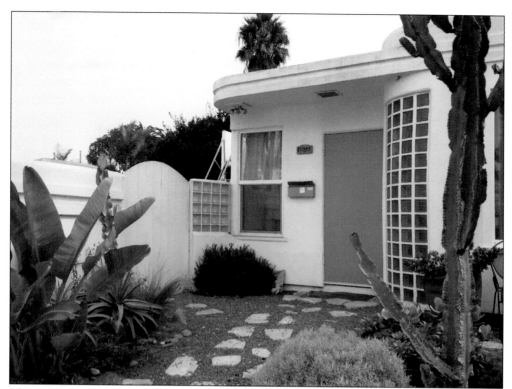

This 1930s Art Deco home on Sunset Cliffs Boulevard near Saratoga Avenue utilized trendy glass bricks in its design. Today, it stands as an example of Ocean Beach's eclectic architecture.

Most of Southern California's bungalow courtyards, such as this one on Bacon Street, were built between World War I and World War II. This dwelling arrangement, with its common areas and proximity to neighbors, remains popular to this day.

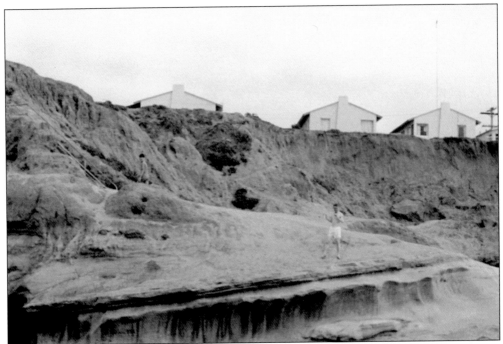

This 1969 photograph shows duplexes that were built at the foot of Santa Cruz Avenue during World War II. These and others in Ocean Beach sprung up to meet the housing shortage caused by a wartime boom in population. Duplexes, which supplied housing for two families in one building, were economical to construct and took up less space than two separate homes. The Santa Cruz site is now occupied by a large condo complex. (Courtesy of Steve Rowell.)

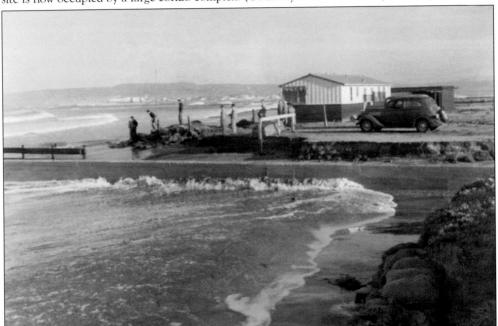

About 1940, the Angelman family occupied one-half of this precariously positioned duplex at the foot of Cape May Avenue. The home was destroyed during a severe storm a short time later.

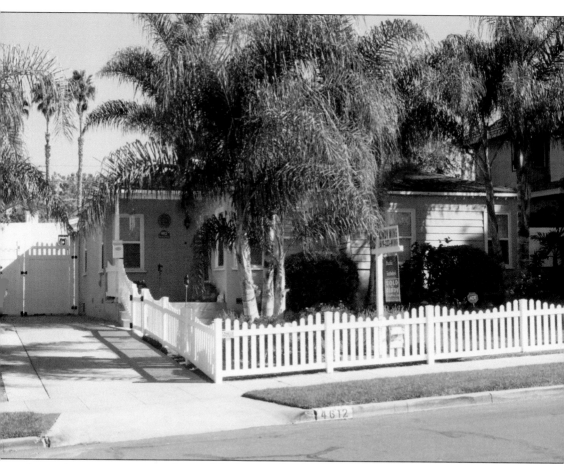

In another attempt to meet the need for housing during World War II, a large number of homes were built from 1943 to 1944 just south of Point Loma Avenue in the once pricey, architecturally restrictive Sunset Cliffs subdivision. The federal government's Office of Price Administration overturned restrictive covenants, allowing the construction of moderately priced identical homes, which had three bedrooms and one bathroom. The houses came with built-in tile tubs because regular bathtubs were unavailable at the time, and garages were not included as the area was well served by city buses. Most of these homes have been remodeled and are unrecognizable today. (Courtesy of Steve Rowell.)

World War II veteran Everett Charles Gerrow stands in front of his Marseilles Street home in Azure Vista, a housing project in the Sunset Cliffs area. With 400 family units, Azure Vista was one of several such projects built in San Diego by the federal government to accommodate defense plant and military workers and their families. Azure Vista's boundaries were Sunset Cliffs Boulevard, Hill Street, Cornish Drive, and Ladera Street. Although the war ended in 1945, the barracks-style multi-family units remained occupied until 1957, at which time the buildings were sold and moved and the empty lots auctioned off. In the 1940s–1950s, Ocean Beach was also neighbor to the Frontier Housing Project in the Midway area, which had 3,500 units.

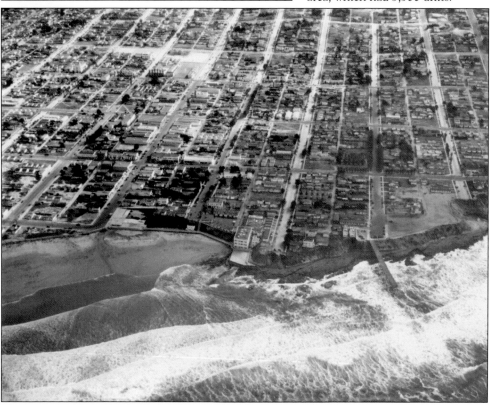

This 1947 aerial view shows a densely populated Ocean Beach with only a few vacant lots. The community had come a long way since 1910, when it boasted of having 100 houses!

Five

DEVELOPMENT

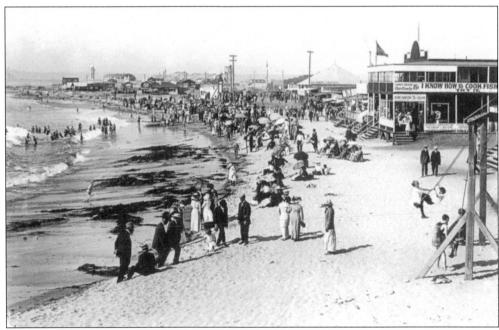

One of the earliest businesses on the beach was Henry Krotzer's two-story fish house (upper right),
built in 1909 at the foot of Niagara Avenue. In 1914, Budd Carberry purchased the two-story
redwood building and for the next 15 years served fish, mussels, and clams in what he called the
"farthest southwest restaurant in the United States." The sign on the side of "Budd's Fish House"
proudly proclaimed, "I Know How To Cook Fish."

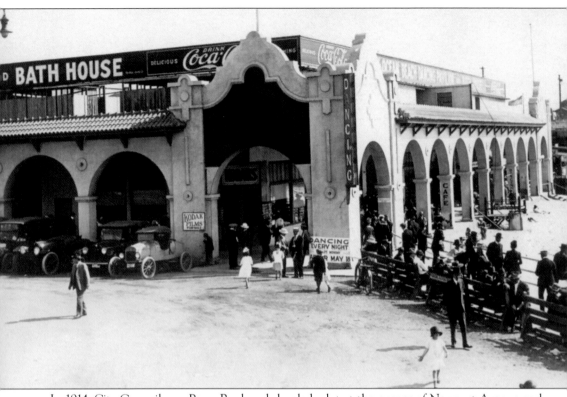

In 1914, City Councilman Percy Benbough leveled a lot at the corner of Newport Avenue and Abbott Street (the site of today's pier parking lot) and erected a two-story bathhouse and dance hall, digging down 17 feet to bedrock to provide a firm foundation. In 1918, the building was extensively remodeled at a cost of $80,000, resulting in a ballroom that could accommodate 1,400 dancers on the ground floor and a bathhouse with 500 dressing rooms on the second floor. The building, which was managed by Percy's cousin W.E. Benbough, also housed a restaurant and pool hall. In Benbough ads of the day, the venue was called the "largest, smoothest, and coolest dancing pavilion in Southern California." According to *Beach Town* author Ruth Held, during Prohibition, the establishment had "discreetly draped booths, so the customers mixing their own liquor with the ginger ale wouldn't be too obvious to any probing investigators." Benbough sold the building in 1928, and it was torn down in January 1941.

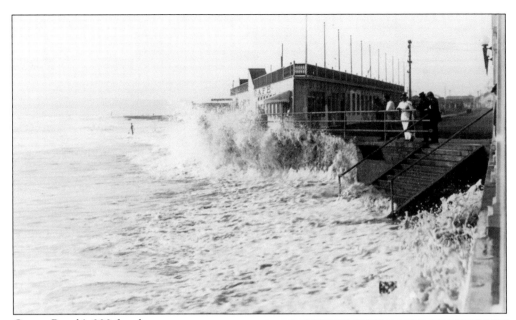

Ocean Beach's 200-foot-long flatiron building, built at the foot of Newport Avenue in 1914, was seriously damaged by a nasty winter storm in 1915, but managed to hang on. The repaired building became a beach fixture over the next three decades, during which it provided a home for several popular beach businesses, including "Mac" McPhetridge's hamburger joint from 1922 to 1941. The Ocean Beach Women's Club, founded in 1924, also rented space in the building from 1927 to 1941.

In October 1941, the Women's Club and Mac's hamburger joint were forced to find new accommodations when the flatiron building was demolished during yet another horrendous storm. Today, the site where this building once stood is a triangular grassy area with memorials to veterans and lifeguards.

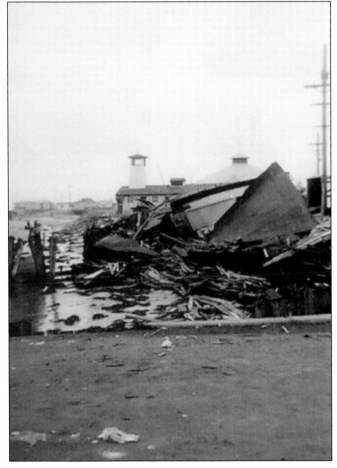

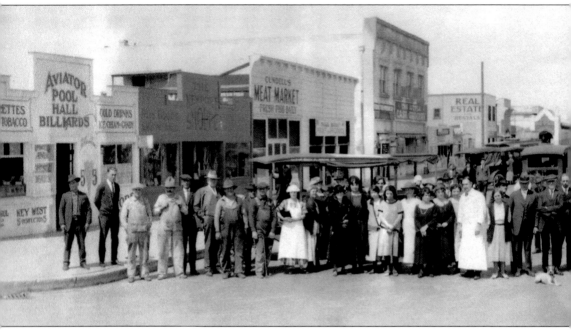

By the time this photograph was taken in the early 1920s, Ocean Beach's business district had formed along several blocks of Newport Avenue. These Ocean Beach merchants took time off from their busy day to pose at the intersection of Newport Avenue and Bacon Street. A number

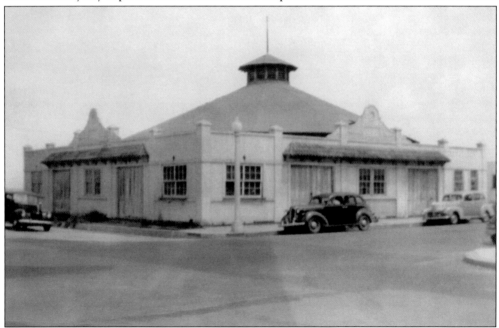

In 1918, Oliver F. Davis moved his 1911 Herschell-Spillman merry-go-round from San Bernardino County to Ocean Beach, where it remained for the next nine years at the foot of Newport Avenue. The ride cost 5¢ regardless of age, and Davis also provided a free picnic pavilion with tables to seat 120 people. The carousel was moved to Los Angeles in 1927, but the building that housed the ride stayed and was an Ocean Beach landmark until 1965, when it was finally torn down.

of the buildings that were erected during this period remain today. Although most have been remodeled and repurposed over the decades, their underlying architecture is a reminder of a long-ago era.

This 12-foot-wide boardwalk connecting the Benbough dance pavilion (at the foot of Newport Avenue) with the new Silver Spray Plunge (at the foot of Niagara Avenue) was dedicated on June 21, 1920. A second boardwalk stretched north along the beach from Newport Avenue to Cape May Avenue and provided delightful year-round strolling for visitors and residents alike.

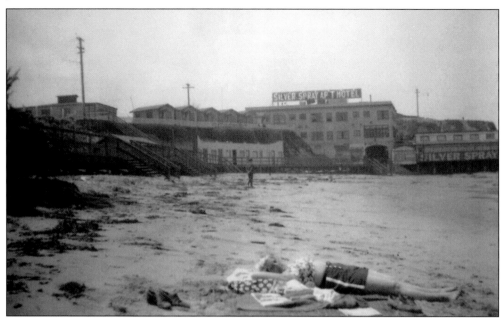

The Silver Spray Apartment Hotel and Plunge was built in 1919 at the foot of Narragansett Avenue, just above the tide pools. Made of reinforced concrete, the $80,000 plunge was the largest in Southern California at the time (100 feet by 65 feet), and it quickly became a hit with locals and tourists. It cost 25¢ to swim in the heated saltwater pool or 35¢ with a swimsuit rental included. The management assured bathers that "clean water flows through continuously from the inexhaustible supply of the Pacific Ocean."

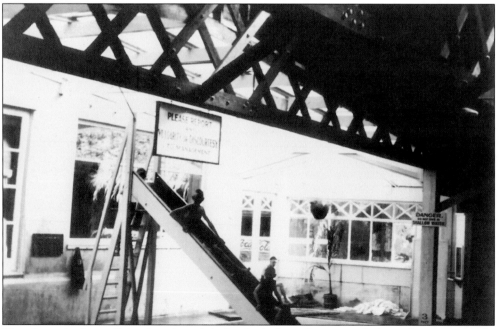

The plunge had two diving boards, a slide for the kids, and a narrow balcony for spectators. In this 1921 photograph, two local boys, Glen Cords (near top of slide) and his cousin Leo Stehr, can be seen at play.

This ad from Silver Spray's heyday touts all the services available at the resort. Among the serious swimmers who frequented the plunge were Florence Chadwick, who went on to break English Channel records, and Faye Baird, said to be Southern California's first woman surfer.

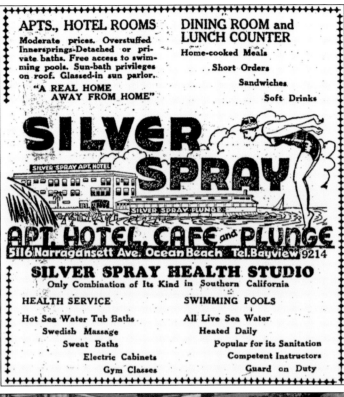

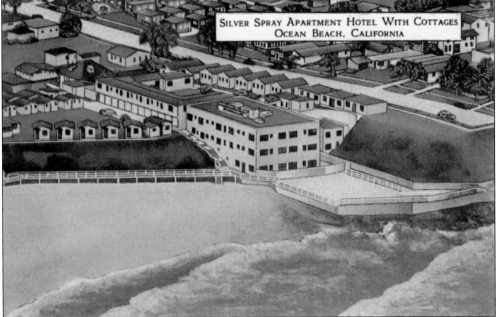

SILVER SPRAY APARTMENT HOTEL WITH COTTAGES OCEAN BEACH, CALIFORNIA

This postcard shows the Silver Spray Apartment Hotel after the plunge building was demolished (1947) and the pool filled with sand. Locals today refer to the former pool as "The Sand Box." Still going strong are the Silver Spray Apartments, available to renters who want to live within a stone's throw of the Pacific.

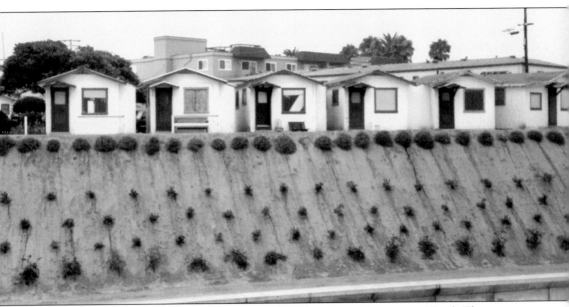

Camp Holiday opened in 1923 adjacent to the Silver Spray Apartment Hotel. The one-room beach cottages were built at the end of Niagara Avenue on property owned by Mary Peace and were managed by her son-in-law, Frank McElwee, an Ocean Beach real estate agent. By the early 1920s, many families were beginning to hit the road at vacation time, and to accommodate them, auto courts sprung up across the nation. At Camp Holiday, car travelers enjoyed being able to pull their cars right up next to their rented cottages overlooking the ocean. In 1925, the units rented for $10 a month.

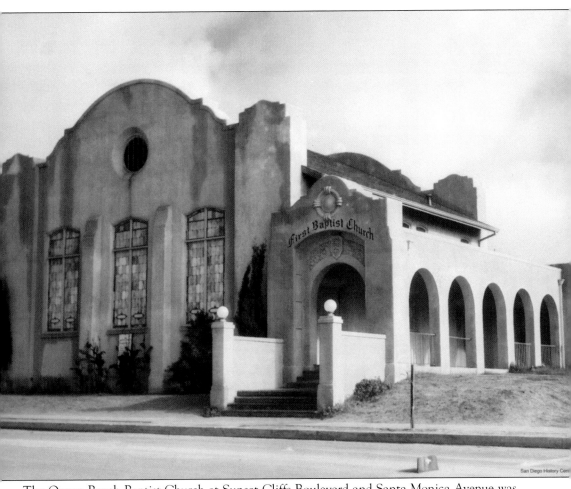

The Ocean Beach Baptist Church at Sunset Cliffs Boulevard and Santa Monica Avenue was built in 1923 at a cost of $15,000. During the nine years prior to the erection of this building, the congregation had met in temporary homes, including a tent cottage. The first church to be built in Ocean Beach was the Union Congregational Church, erected in 1913 on Santa Monica Avenue. According to one news account, the 30-by-40-foot building was completed in a single day. This first house of worship pledged to serve Ocean Beach residents of all denominations since no one denomination had sufficient members to support a church of its own. Another early church was the Chapel of the Sacred Heart, a $1,000 frame building dedicated on May 17, 1914, on the corner of DeFoe Street (now Sunset Cliffs Boulevard) and Santa Monica Avenue. As more churches opened in Ocean Beach, such as the Point Loma United Methodist Church in 1928, they tended to locate on Sunset Cliffs Boulevard, earning the main entryway into Ocean Beach the nickname "Church Row."

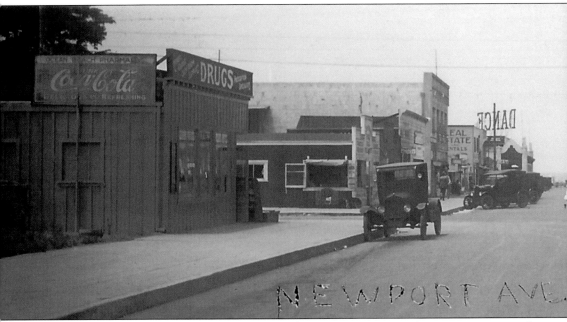

This west-looking view shows commercial development on Newport Avenue just prior to the building boom of 1927–1928 that dramatically changed the look of Ocean Beach's main street. A sign advertising Benbough's dance pavilion, still going strong at the end of the street, can be

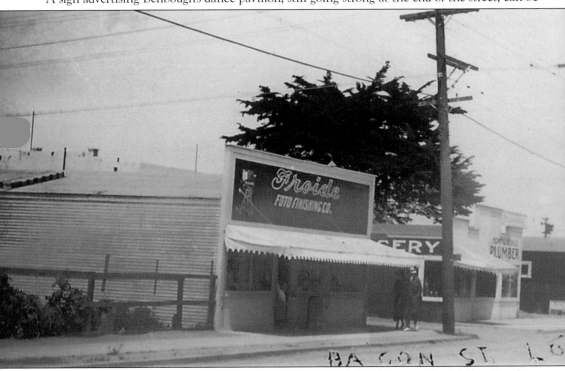

Bacon Street was second to Newport Avenue in commercial development. Froide's Foto Finishing (left) was a leader in the days when film was king and was also home to Ocean Beach's Western Union telegraph office, the place people went when they had to send a message fast. Everyone

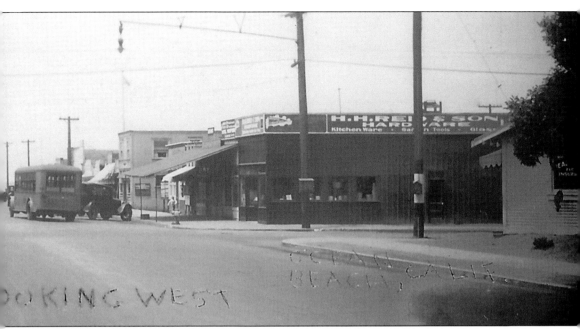

seen at left center. Today, several Ocean Beach businesses, including The Black, South Coast Surf Shop, and Sapporo, are housed in pre-1920 buildings on the south side of Newport Avenue.

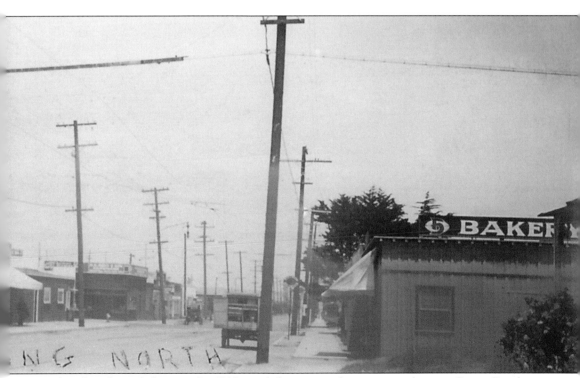

got their bread in a bakery in the 1920s, and there were always two or three in Ocean Beach, including this one on the right.

The Ocean Beach Woman's Club (OBWC) was founded on November 24, 1924, "to work for the community in its civic, educational, and social development." From 1927 to 1941, the club leased the flatiron building as a meeting place and remained there until October 1941, when high tides demolished the structure. In March 1944, the club was able to purchase for $1,350 a building that had started out as a church and was later used as an Ocean Beach Elementary School bungalow. The women then moved the building to donated land on the corner of Muir Avenue and Bacon Street, where it has been used as a clubhouse ever since.

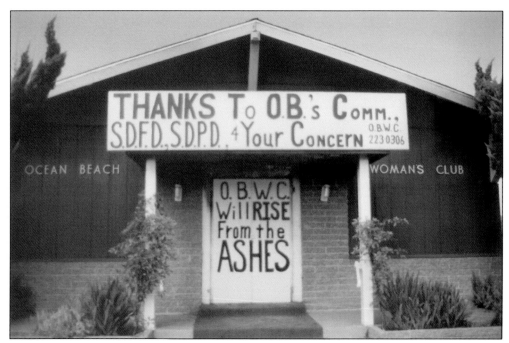

On September 21, 1997, the OBWC building sustained major fire damage, but the club came back stronger than ever with the help of the community.

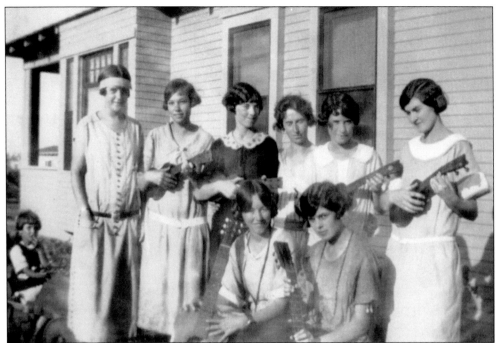

A fun project of the Ocean Beach Women's Club was its all-female ukulele band, organized shortly after the club formed in 1924. Members included Ruth (Varney) Held (sitting, right), who decades later wrote the Ocean Beach history book *Beach Town*, and Ruth (Shepherd) Vallin (standing, far right), who died a week shy of her 106th birthday in 2012. A popular song in 1926 was "Oh How She Could Play a Ukulele."

Ray Ericsson of the Ocean Theater, Ocean Beach's first movie house, built the 500-seat Strand Theatre (center) on Newport Avenue in 1925. Throughout its first 50 years, the Strand showed standard Hollywood fare, but in the 1970s, it became one of the first theaters in the country to feature *The Rocky Horror Picture Show*. It also had a short stint as a porn theater before finally closing its doors in 1998.

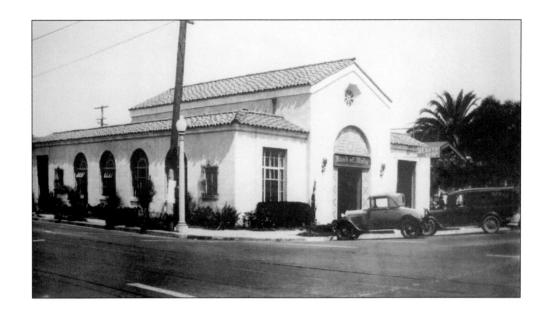

The Bank of Italy, Ocean Beach's first bank, opened on the corner of Newport Avenue and Bacon Street in March 1927. The Spanish-style building was designed by noted architect William Templeton Johnson, whose most famous San Diego project would be the Junipero Serra Museum in Presidio Park (1929). The interior of the Bank of Italy was stylish, with marble counters, chrome teller windows, and antique mahogany woodwork. Following a merger in 1930, Ocean Beach's one and only bank became the Bank of America and went on to serve the beach community for the next four decades. For a short time in the 1970s, the building was home to the Left Bank bookstore, but later that decade, the Ocean Beach branch of Peninsula Bank was located there. By the 1990s, it had morphed into Java Joe's, a coffee house where many musicians got their start. Today, it is a Starbucks.

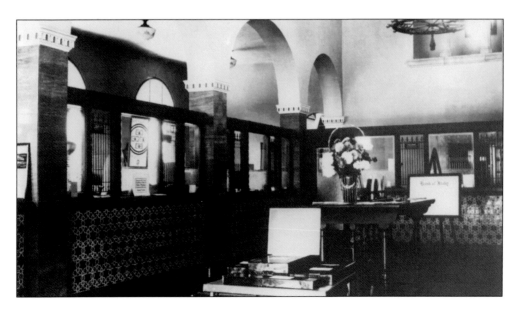

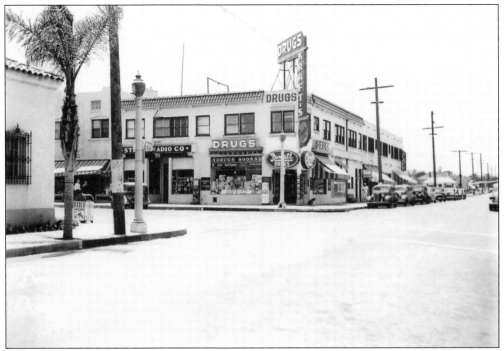

The two-story Kraft Building, dedicated in January 1927, housed the Kraft Drug Store and soda fountain and several other shops on the ground floor and apartments and medical and dental offices upstairs. Pharmacist Fred H. Kraft was owner and operator of the drugstore located at the busy corner of Newport Avenue and Bacon Street. Today, the ground floor is home to a convenience store.

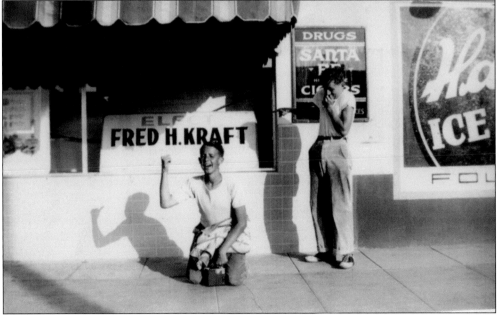

These young men thought it was funny when the local pharmacist ran for office, but Fred Kraft managed to win the 1942 election and become a state senator.

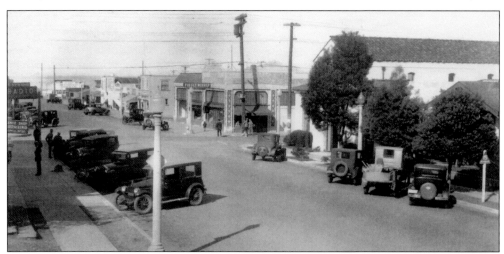

In this late 1920s street scene looking west, the only trees on Newport Avenue are those surrounding the newly opened Bank of Italy.

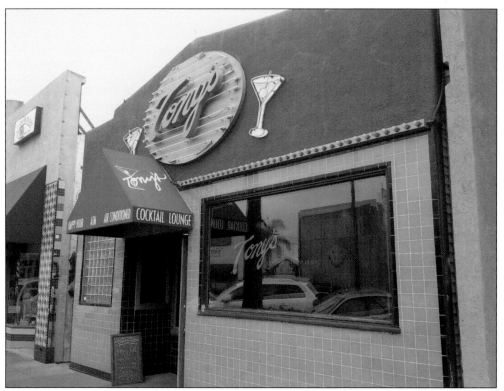

Owner Anthony Matovich operated De Loma Fountain in 1927 at this site before it became Tony's cocktail lounge. The original store was a confectionery, but it also sold newspapers, magazines, cigars, and cigarettes. Once Prohibition was repealed in 1933, the place took on a new name and a new product: booze. The busiest days for Tony's came during World War II, when the 5000 block of Newport Avenue was filled with bars, card rooms, pool halls, and arcades for the entertainment of servicemen and defense workers.

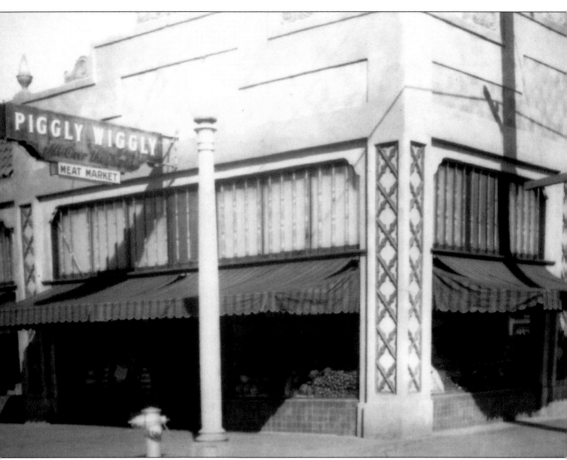

Piggly Wiggly, an early self-service franchise grocery store, opened on Newport Avenue near Bacon Street on June 23, 1928. Shoppers used woven baskets provided by the store to collect their fresh produce, packages of meat, and other food items before proceeding to the checkout stand, a Piggly Wiggly innovation. In 1929, a one pound can of coffee cost 45¢, a six pack of Coca Cola was 25¢, prime rib roast cost 32¢ a pound, and peaches sold for 5¢ a pound. Piggly Wiggly stressed the self-service concept for the "woman of today:" "She needs no clerks to persuade her. She comes to Piggly Wiggly and chooses for herself." After the store closed about 1951, the building housed several other grocery stores, including Newport Farms, which opened on July 4, 1977, and is still there today.

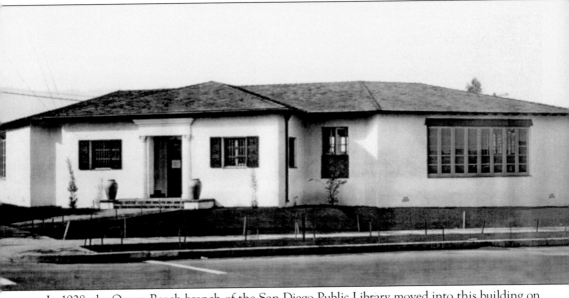

In 1928, the Ocean Beach branch of the San Diego Public Library moved into this building on a 100-by-100-foot lot at the corner of Sunset Cliffs Boulevard and Santa Monica Avenue. (For the previous 12 years, the branch had operated out of a storefront on Abbott Street.) Robert W. Snyder, who studied under renowned architect William Templeton Johnson, designed the Spanish-Monterey structure, which was designated a historic landmark in 2002. Construction costs, including purchase of the lot and the library's furnishings, came to about $19,000. Margaret Rankin, a 1912 graduate of Ocean Beach Elementary School, served as librarian from 1921 until her retirement in 1959. According to an August 4, 1929, newspaper article, the branch was open "every afternoon and evening from 2 o'clock until 8." The library expanded to its present size in 1962, and the two urns near the front entrance were added in 1993 to replace the original ones, which had been damaged.

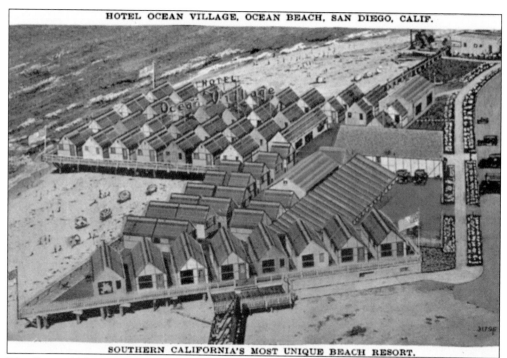

SOUTHERN CALIFORNIA'S MOST UNIQUE BEACH RESORT.

The Ocean Village Hotel, built on West Point Loma Boulevard in 1928, was a popular beach resort in the 1930s and 1940s. Built on pilings from the old Wonderland amusement park, the resort rented out 100 completely furnished "bungalettes" (cottages) that ranged in size from a hotel room to a double apartment. Guests could also enjoy Ping-Pong, billiards, cards, and dancing in the hotel's large lobby, or boating and canoeing on nearby Mission Bay.

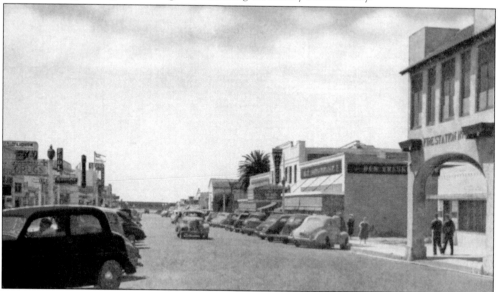

This 1930s postcard shows Ocean Beach's two-story fire station (far right) on Newport Avenue between Cable and Bacon Streets. From 1915 until the mid-1930s, the station's service area included Mission Beach, La Playa, and Point Loma. By 1949, Ocean Beach's firefighters had moved into their new building at Ebers and Voltaire Streets.

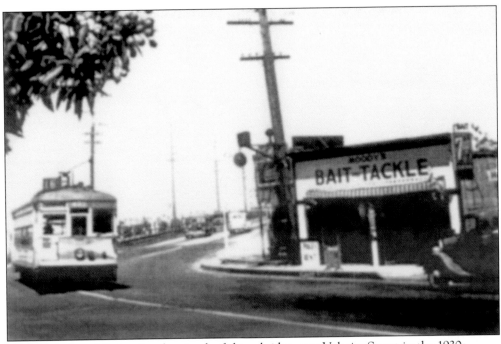

A streetcar from Mission Beach exits the fishing bridge onto Voltaire Street in the 1930s.

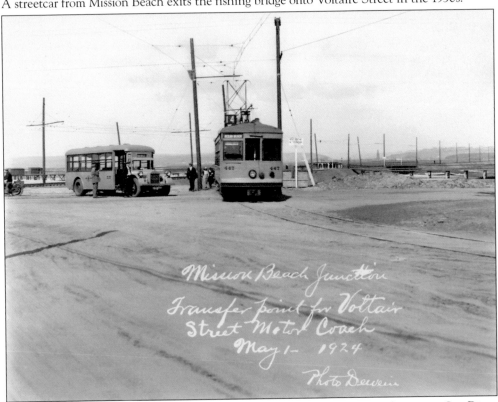

Passengers from Mission Beach and parts north who wanted to continue to downtown San Diego transferred at Voltaire and Bacon Streets.

Ocean Beach's first farmers market dates back to the late 1930s and was held on Newport Avenue, as it is today. One of the regular participants in this venture was hired away in 1940 to manage the new Safeway store.

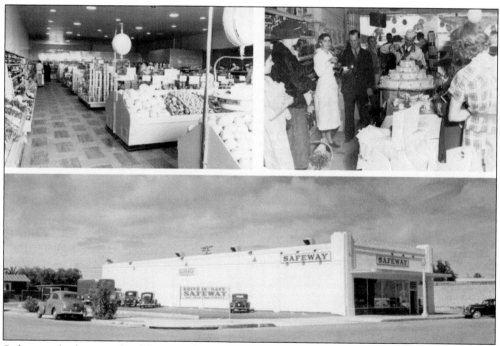

Safeway, which opened at Newport Avenue and Cable Street about 1940, was the first grocery store in Ocean Beach to have a parking lot. It was also one of a handful of San Diego Safeways to be open on Sunday, unusual for that era. After the store relocated to a larger site at Cable Street and Santa Monica Avenue about 1960, the old building was home to several succeeding furniture stores until 1977, when the fledgling James Gang Graphics and Printing moved in. In 1990, the print shop moved to Bacon Street (the old Ocean Beach Bowl), and Mallory's New Furniture Store took over the Safeway building.

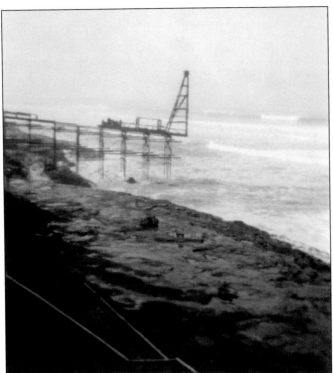

In mid-1941, construction on a steel fishing pier at the foot of Del Monte Avenue got underway, with funding for the $165,000 project provided by San Diego's Harbor Department and the federal government (WPA). Salvaged steel railroad rails were used as building material.

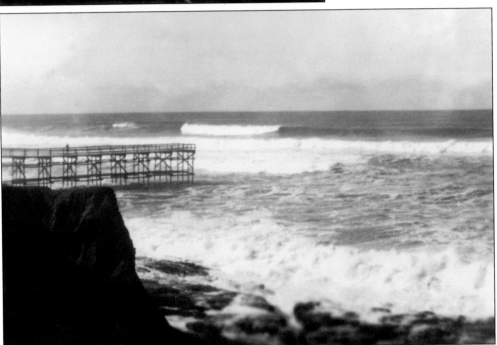

The original plans called for the pier to be 20 feet wide and to extend 2,000 feet out to the kelp beds, but by 1942, it had only reached a length of about 300 feet. (Construction had been stopped shortly after the war began due to scarcity of labor and materials.) In 1951, the pier was condemned and barricaded to public use, and in 1953, it was torn down.

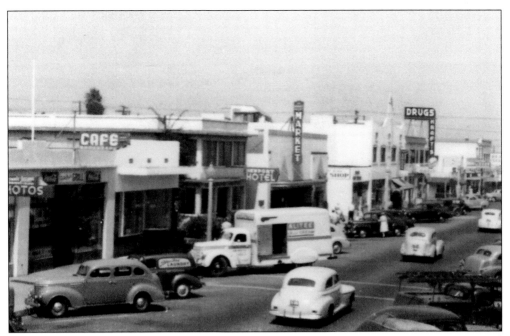

By the 1940s, Ocean Beach was beginning to look like Main Street America—a self-contained community with businesses that provided just about everything one needed in this much simpler time.

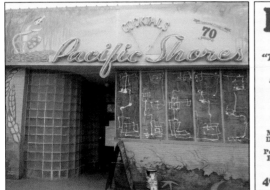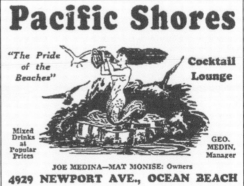

This legendary local bar opened on December 7, 1941, a "date that will live in infamy." Despite its ominous beginning, Pacific Shores was an immediate success and remains a popular hangout to this day. One distinguishing feature of this cocktail lounge is its curved bar, said to be the first in San Diego.

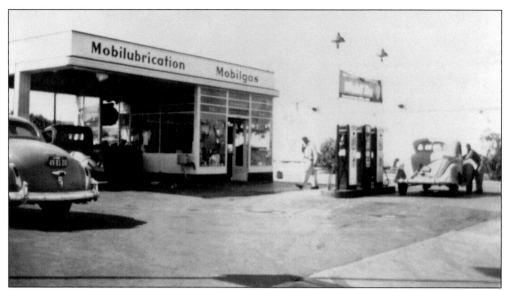

Myers and Stuart Mobil Station, which opened on December 31, 1941, did business on the corner of Newport Avenue and Cable Street for over half a century. Proprietor Bob Myers was ever helpful, often not charging his customers for changing tires and other services. He won respect during World War II for being able to keep many Ocean Beach cars running when parts were scarce.

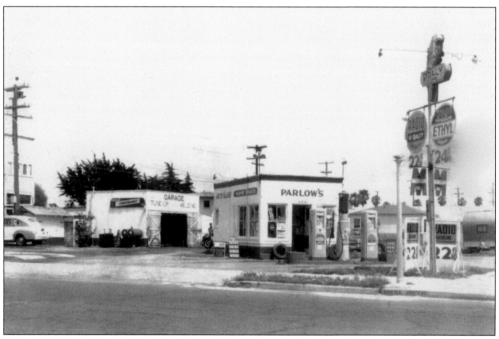

Parlow's garage and gas station, on the corner of Abbott and Voltaire Streets, was a popular fueling stop in the 1940s. Gas stations were called service stations in those days for a good reason—an attendant not only pumped customers' gas, but also washed their windshields and checked their oil and water. Motorists of the day, however, probably grumbled about the high price of gasoline at 22¢ a gallon.

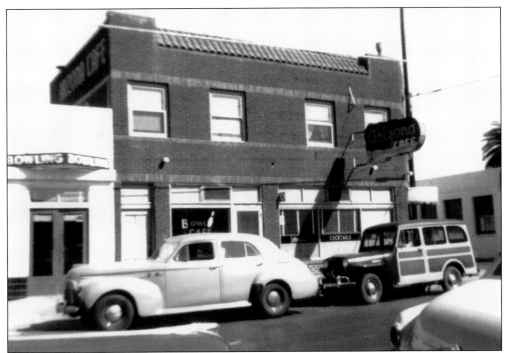

In 1943, former boxer and football player George Radovich opened the Arizona Café on Bacon Street in a 1927 building purchased by his father, an Arizonan, the previous year for about $8,000. The first Arizona Café menu listed hamburgers for 20¢ and beer for 15¢. Robert Radovich, George's son, later took over the restaurant and operated it until 2006, when it was purchased by John Small.

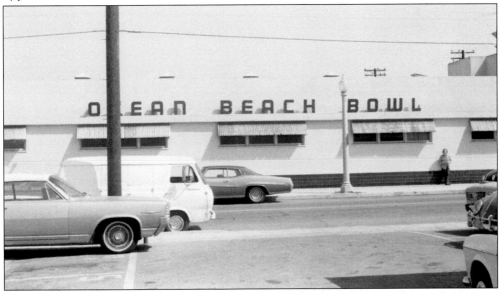

In 1946, the Radovich family opened one of the area's first bowling alleys next door to the Arizona Cafe. The Ocean Beach Bowl went on to provide inexpensive recreation for OBceans for several decades during the heyday of bowling. After it closed in 1982, Ty's Printing operated at this address until 1990, when James Gang Graphics moved from Newport Avenue to this location.

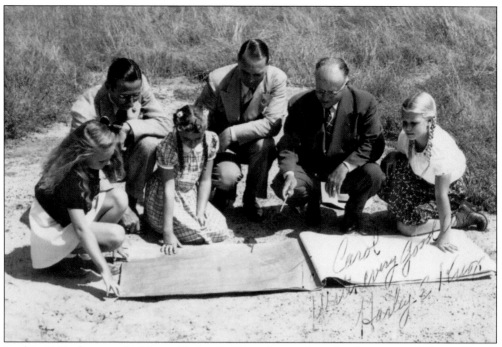

In this 1944 photograph, Mayor Harley E. Knox shares plans for the proposed Ocean Beach Recreation Center with, from left to right, Sally Bonham (Mozingo); Carol Hart (Bowers), future cofounder of the Ocean Beach Historical Society; and Jeanne Lilly (Milton). The girls helped raise money for the center, to be built on Santa Monica Avenue across from Ocean Beach Elementary School, by selling flowers and hosting a backyard carnival. The PTA and the Ocean Beach Women's Club were also involved in fundraising efforts.

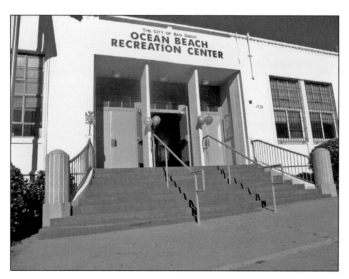

The Ocean Beach Recreation Center, designed by architect William Templeton Johnson, was dedicated on April 10, 1947, to the delight of an audience of 750 men, women, and children. It cost $75,000, with $10,000 raised by the people of Ocean Beach and the remainder covered by the city. The facility, which still operates today, provided play equipment, athletic fields, and recreational activities for both children and adults.

The Cubby Hole restaurant near the lifeguard station was a popular snack bar for beachgoers during this era. Foot-long hot dogs were the fast food of the time.

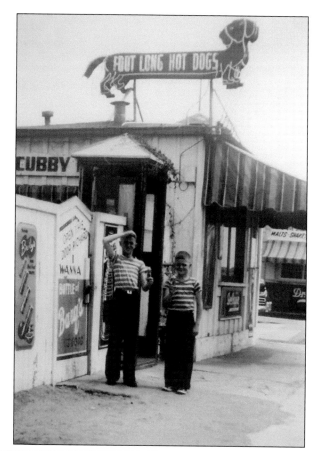

This view looking south from the Cubby Hole to the Silver Spray Apartment Hotel reveals a very wide sandy beach in pre-pier days.

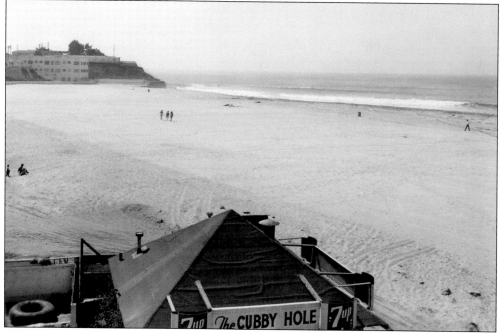

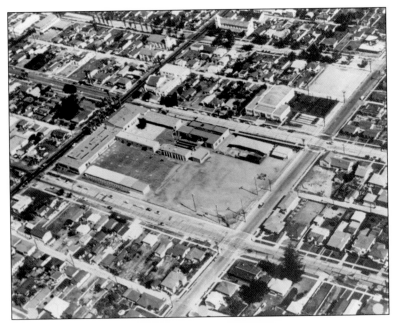

This late 1940s aerial photograph shows Ocean Beach Elementary School, which by this time had grown to fill an entire city block, and the new recreation center across the street on Santa Monica Avenue.

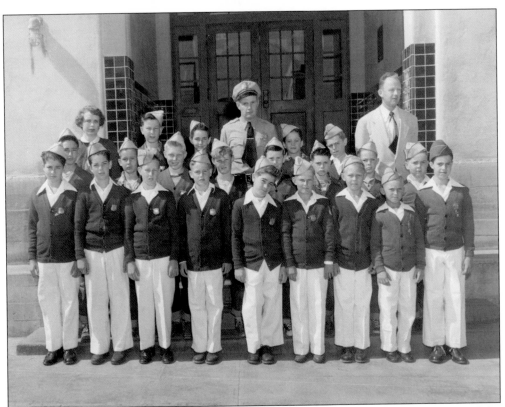

Ocean Beach Elementary School crossing guards pose for a photograph on the stairs of the Spanish-tiled entrance to the school in 1949. The boys worked under the supervision of a police officer, who taught them how to march, follow orders, and safely stop traffic.

Six

BEACHES AND CLIFFS

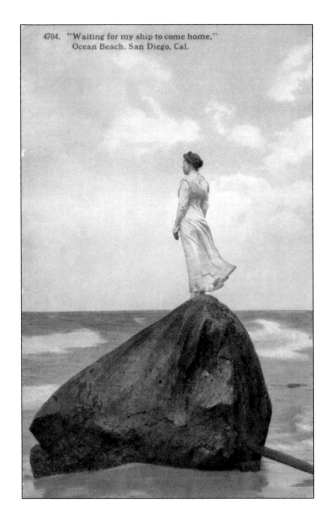

In this romanticized 1913 postcard, a lovely lady stands on a rock and gazes out to sea as the waves lap the shores of Ocean Beach. According to the postcard caption, she was waiting for her "ship to come home," although there would have been no place for it to berth in Ocean Beach.

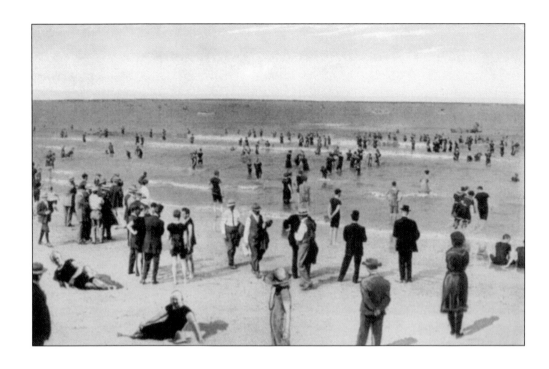

There was no market for sunscreen when these early beach scenes were taken. Whether bathers or spectators, people came to the beach fully dressed.

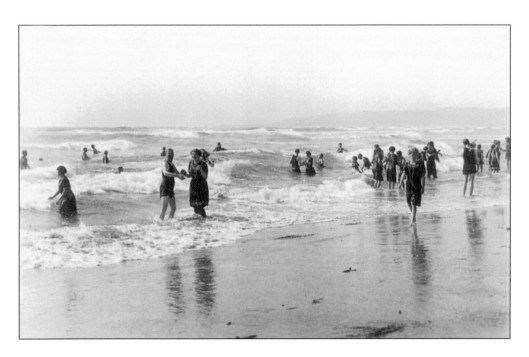

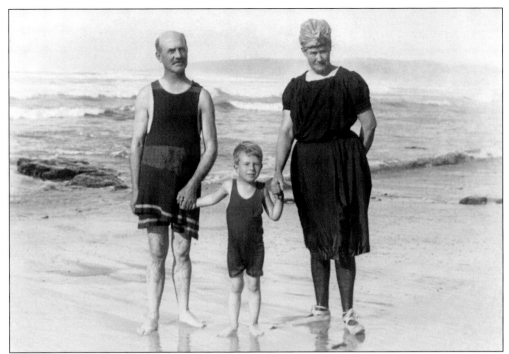

The man in this family photograph sports a black wool suit with a little skirt, typical for the early 1920s, while the woman wears a head-to-toe swim garment that would not be complete without ballet slippers for her feet. The little boy appears to be the best "suited" for swimming and may even get wet.

The warm sand was inviting after a cool dip in the Pacific. These beach lovers are relaxing at the end of Newport Avenue.

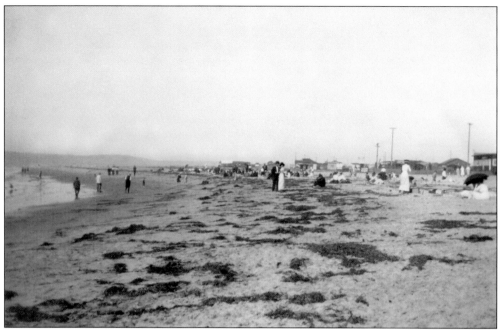

Kelp piled up on the sand (as seen above) has long been a common sight at the beach after a high tide, and the kelp beds off Ocean Beach are some of the largest in the world, ensuring a constant supply of the messy seaweed. In 1939, a storm caused so much kelp to pile up around the Ocean Beach police substation that city trucks had to be called in to haul it away. Kelp does have its good points, though. Southern California's offshore kelp beds provide a rich habitat for a variety of sea creatures, and alginate derived from kelp—which has been harvested off the coast of San Diego since 1911—is used in dozens of food products, including ice cream. The boys below knew what to do with kelp: play with it! In this 1916 photograph, brothers Alfred and Ralph Cobb amuse themselves in front of the Benbough bathhouse at the foot of Newport Avenue.

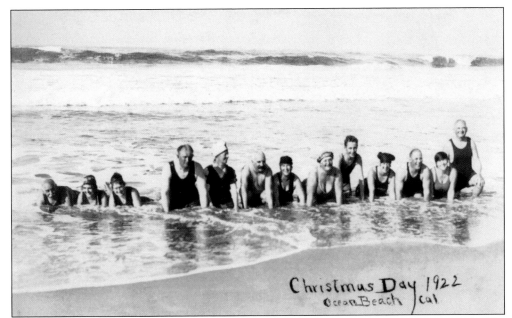

This group of bathers thought Christmas 1922 was a great day to take a dip at Ocean Beach. The photograph was made into a postcard, undoubtedly so these folks could brag to friends in colder climes about Ocean Beach's near-perfect weather.

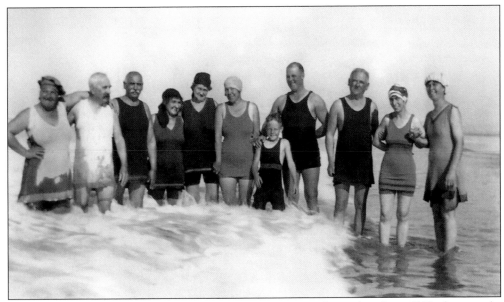

New Year's Day presented another opportunity to romp in the surf as these 1923 photographs attest. Were these the same hardy souls who posed a week earlier? The average ocean temperature in January is 59 degrees—brrrr!

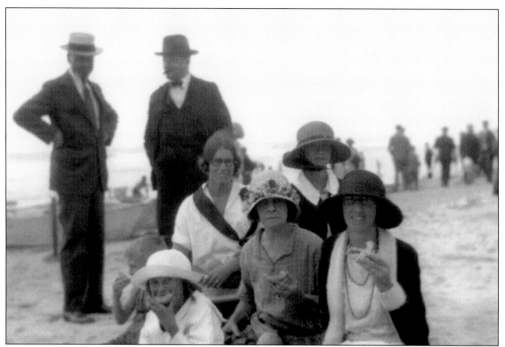

Ocean Beach was also a great spot for a picnic. This 1930s photograph shows the Jack Reick family gathered for an outdoor meal at the foot of Newport Avenue. It may have been a Sunday as they are dressed in their finest, although one family member (center) has apparently lost her hat.

By the 1930s, umbrellas were a common sight on the beach. On the left, a lifeguard dory can be seen parked on the sand. Lifeguards had to paddle these difficult-to-maneuver wooden boats through the surf to rescue swimmers in need of help.

A popular swim area among locals was the False Bay (now Mission Bay) swimming hole. Before Mission Bay was dredged in the late 1940s, northern Ocean Beach was on the bay's southern shore. The area was later developed into Robb Athletic Field.

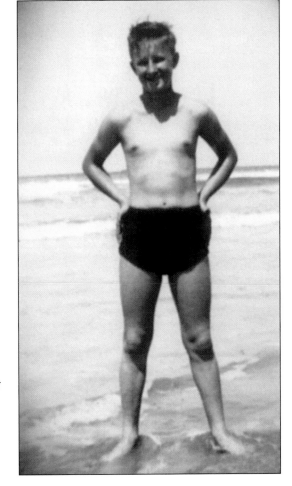

As a young teen, Ned Titlow could not get enough of the beach and swimming. Except for his first four years and another three years in the military, Ned spent his entire life near the Pacific Ocean in his beloved Ocean Beach. The longtime OBcean, who died in 2011 at age 87, was a founding member of the Ocean Beach Historical Society.

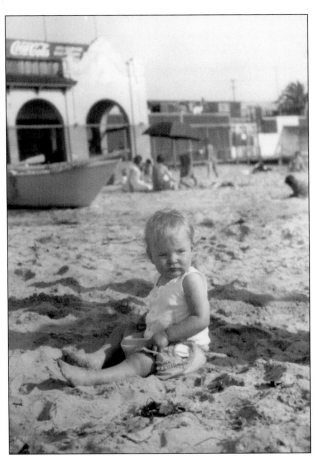

Jane Meiners, a native of Ocean Beach and one year old at the time this photograph was taken, was pretty much raised at the beach. She was very good at staking out her own territory, and nobody dared mess with her sand bucket.

The huge lump at the bottom of this boy's feet is a stingray. Frank McElwee Jr. seems to be in awe of this sea creature, possibly from hearing stories about the painful, but not deadly, sting it can deliver with its long barbed tail. Stingrays are common along the Pacific coast and especially like the warm waters of Southern California.

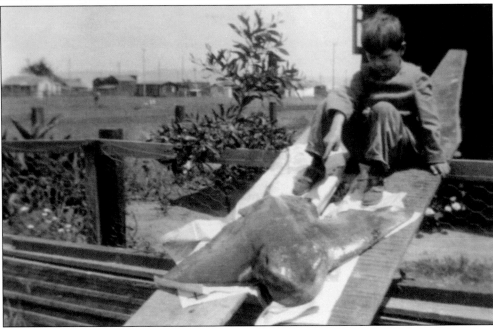

This heavy-duty swing set was reached via stairs that led down from the west end of Niagara Avenue. Apparently, there were no age restrictions.

Hmmm . . . where is that shutter button? This photograph taken of a woman taking a photograph was snapped near the old fish house at the foot of Niagara Avenue. Note the fancy changing rooms for "Ladies" and "Men" at upper right.

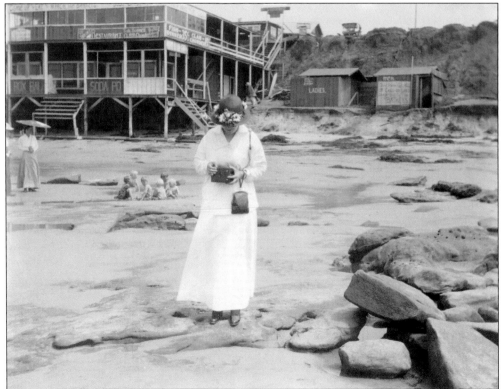

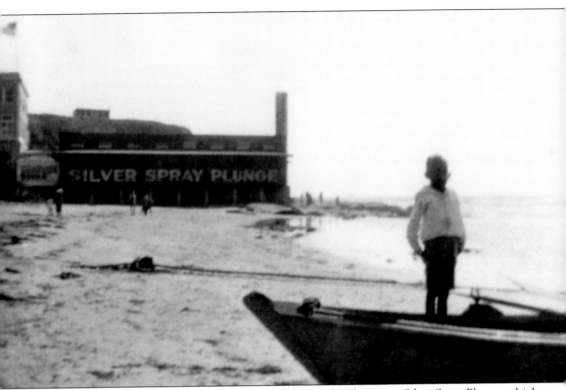

A boy stands in a boat near the south end of Ocean Beach. The iconic Silver Spray Plunge, which opened in 1919, can be seen in the background.

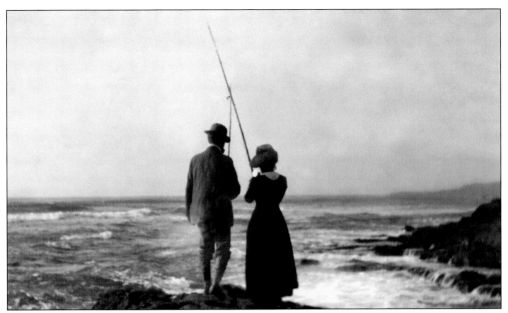

Fishing off the cliffs of Ocean Beach was a popular pastime. Using a long bamboo pole and a heavy weight, fishermen could overhead cast beyond the surf line. Then, they could hand the pole to their sweetie to reel in the catch.

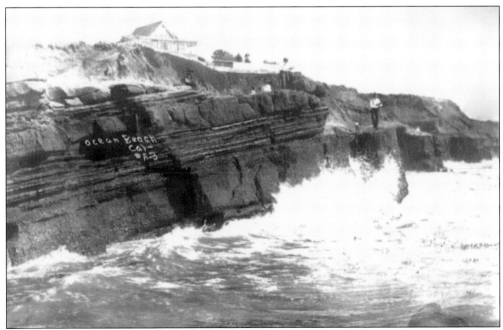

A fisherman tries his luck off the cliffs below Collier's Shack, the home built by D.C. Collier at the foot of Coronado Avenue (then Pacific Avenue) in 1887.

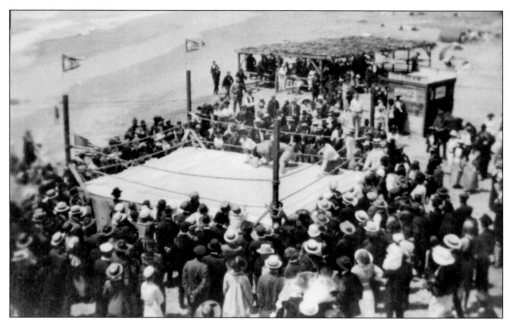

To draw tourists and to entertain locals, Ocean Beach often sponsored special events, such as boxing and wrestling matches on the beach. On July 4, 1918, the Camp Kearny wrestling championship was decided in a makeshift beachside ring, such as shown here.

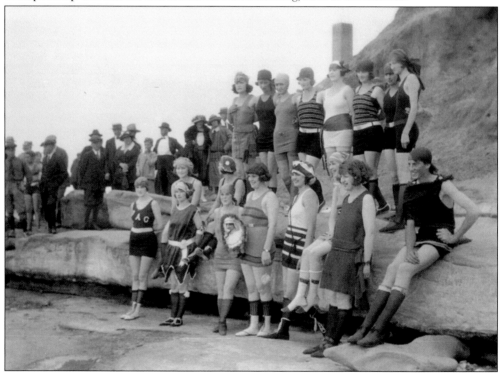

Contestants in a 1920s bathing beauty contest pose on the rocks south of the Silver Spray Plunge. But wait, is that really a member of the "fairer sex" seated at far right? The "beauty" with hand on hip and smirk on face was prankster Jay Turley.

When the strongmen on the beach needed a gal to join them in gymnastics, Maddy Dibble was their go-to girl in the mid-1940s. Although slight in build, Maddy was a weightlifter who could overhead press 100 pounds!

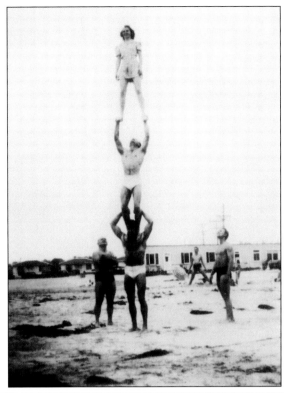

Frank McElwee and Grace Peace, shown here in the sand at the foot of Newport Avenue, met and married in Ocean Beach. Their wedding was held at the Newport Avenue home of Grace's mother, Mary Peace, who owned several prime pieces of Ocean Beach property, including the Niagara bluffs lots on which Camp Holiday, an early auto camp, was built.

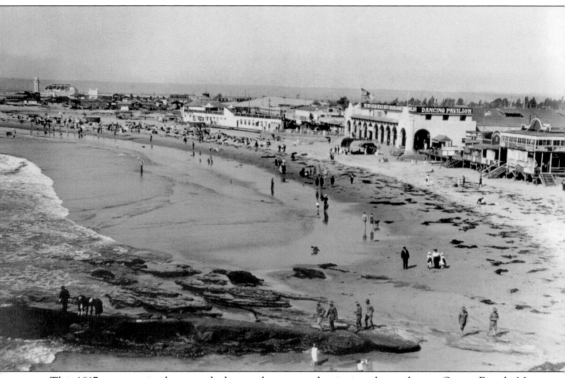

This 1917 panoramic photograph shows a large crowd enjoying themselves at Ocean Beach. Note the World War I soldiers exploring the tide pools in the foreground. With its many attractions, Ocean Beach was a popular destination for servicemen during this era.

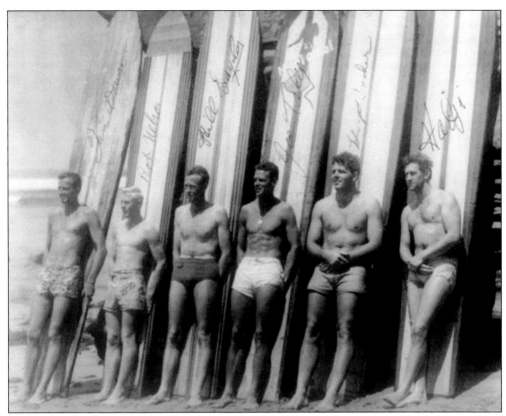

Surfing has long been popular in Ocean Beach, from the northern edge of the community (by Dog Beach) to Sunset Cliffs Natural Park, about three miles south. These surfer hunks from the 1940s, seen here with their wooden plank boards, were regulars in the water off Sunset Cliffs. From left to right are Kimball Daun, Rob Nelson, Bill Sayles, Joe Todye, Lloyde Baker, and Bill "Hadji" Hein.

The Sunset Cliffs surfers, by now all seniors, recreated their original photograph 50 years later. Four of the boards seen here are ones used in the earlier shot. These men exemplify the expression, "Old surfers never die, they just paddle away."

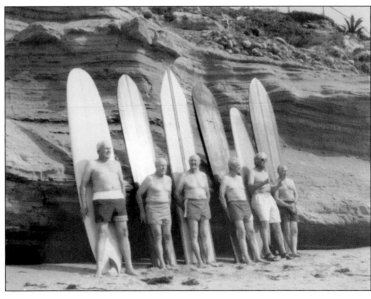

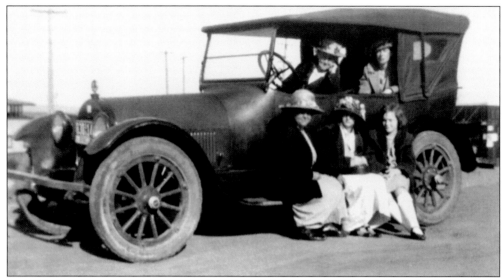

In 1924, this three-generation group of modern California woman, including the Pollock girls, enjoyed exploring the Ocean Beach area in their 1922 Dodge touring car.

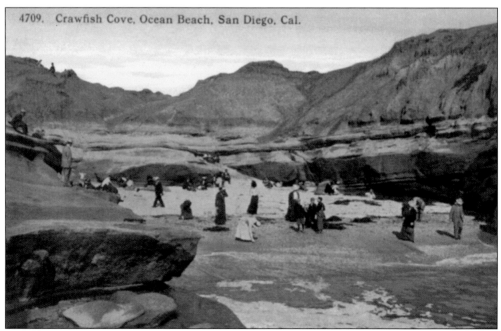

4709. Crawfish Cove, Ocean Beach, San Diego, Cal.

In the 1910s, Crawfish Cove, located at the end of Santa Cruz Avenue, was a popular place for getting one's feet wet and for checking out the tide pools. Houses today perch precariously near the edge of the sandstone cliffs overlooking this scenic spot.

Recognizing the beauty of Ocean Beach's cliffs and rock formations, the City of San Diego erected an observation pavilion high above the water at the foot of Del Monte Avenue, with a stairway leading down to the sandstone ledges.

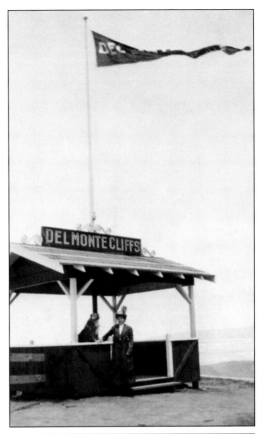

This rock formation, called "Needle's Eye," once stood off Sunset Cliffs. By the 1960s, it had all but disappeared due to erosion.

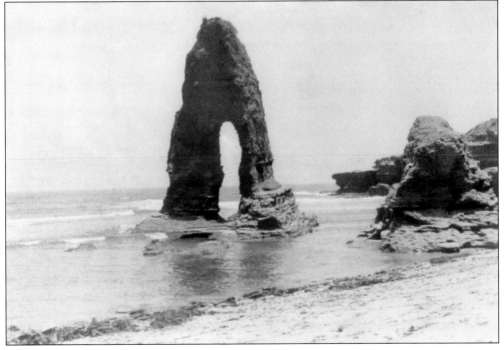

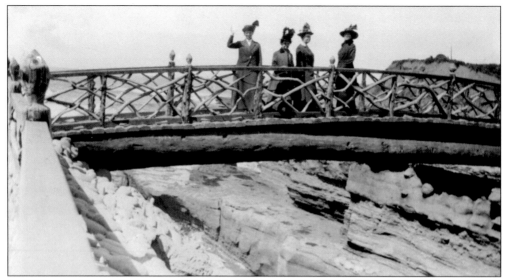

In 1915, sporting goods magnate Albert G. Spalding built a beautiful park along Sunset Cliffs. At the time, he owned all the land between Point Loma Avenue and Hill Street, from Catalina Boulevard to the ocean. These women are crossing a bridge that once stood at Froude Street and Sunset Cliffs Boulevard.

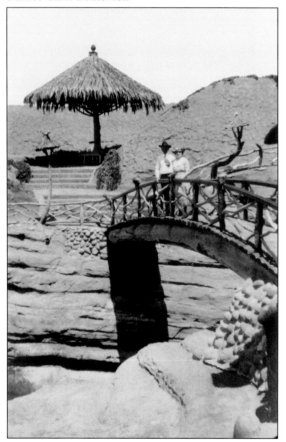

The park had a decidedly Asian theme. Its rustic bridges were designed and built by a Japanese architect hired by Spalding. Other nice touches included cobblestone walls, walkways lined with lavender ice plant, concrete steps leading down the side of the cliffs, and fancy lighting. The $2 million park was a must-see for out-of-towners coming to San Diego for the Panama-California Exposition in 1915–1916. Spalding was still making improvements to the park when he died on September 9, 1915.

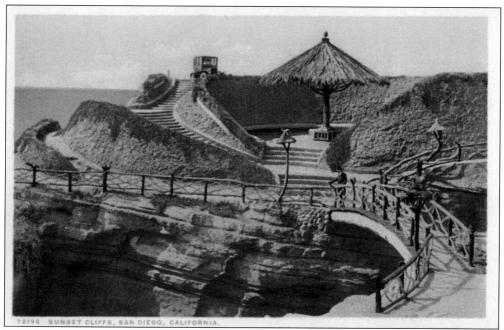

In 1924, John P. Mills bought 300 acres of Sunset Cliffs from A.G. Spalding's widow and refurbished the park. The beautifully landscaped area shown above was directly across the street from the mansion Mills built for himself. By 1926, Mills was spending all of his time developing his Sunset Cliffs subdivision. He gave the park to the City of San Diego, but during the Depression, it fell into disrepair, and the fanciful bridges and shaded gazebos eventually disintegrated or rotted away. Today, a few chunks of concrete and some broken staircases at the bottom of the cliffs are all that remain of what was once an Ocean Beach showplace.

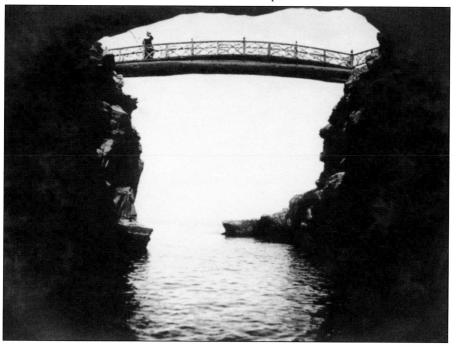

This early photograph shows picnickers exploring the tide pools of Sunset Cliffs at low tide. Although the southern cliffs stretch far beyond Ocean Beach's official street border at Point Loma Avenue, they were considered part of Ocean Beach proper during the early part of the century. Most pre–World War I postcards identify Sunset Cliffs as being in Ocean Beach.

In 1929, a person slipped into a crevice at Sunset Cliffs and had to be rescued by a policeman. Similar mishaps have happened many times since. Cliff visitors are often unaware that rocks that are regularly drenched by salt water are often covered with slippery black algae, called "black ice" by locals, and can cause dangerous slips. Today, posted signs at the cliffs warn visitors of unstable cliffs and other hazards.

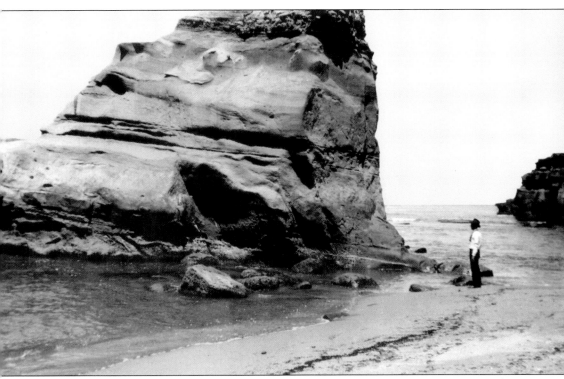

This iconic rock near the end of Froude Street, shown at very low tide in the early 1900s, looks much the same today. Local surfers call this resting place for pelicans, cormorants, and seagulls "Bird Shit Rock" to distinguish it from La Jolla's famed "Bird Rock." Officially known as Ross Rock, it is the southernmost piece in the California Coastal National Monument. This 1,100-mile-long monument is made up of more than 20,000 pieces—small islands, rocks, exposed reefs, and pinnacles.

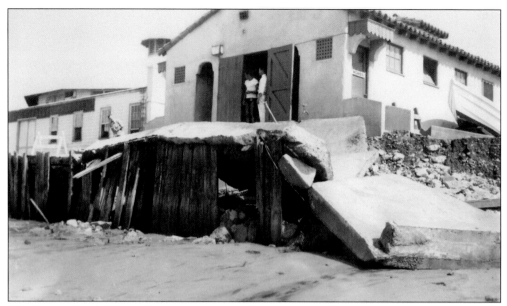

The Ocean Beach lifeguard station on the beach at the foot of Santa Monica Avenue was badly damaged by a severe storm in 1939. Huge waves tore away part of the foundation, but the building was able to be repaired, and a rock barrier was erected to protect it from future storms.

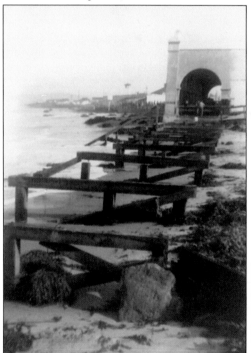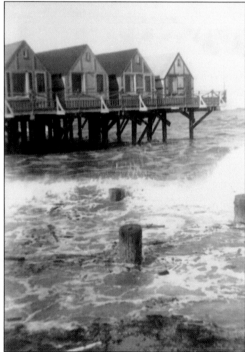

The wooden boardwalk in Ocean Beach (left) was ripped apart by the same 1939 storm that damaged the lifeguard station. Although San Diego receives only 7 to 10 inches of rain annually, torrential rains can occur and often result in low-lying beach areas being flooded. Amazingly, the "bungalettes" at Ocean Village Hotel (right) survived the devastating 1939 storm. This was probably due to the fact that they had been built on sturdy pilings that were anchored to bedrock.

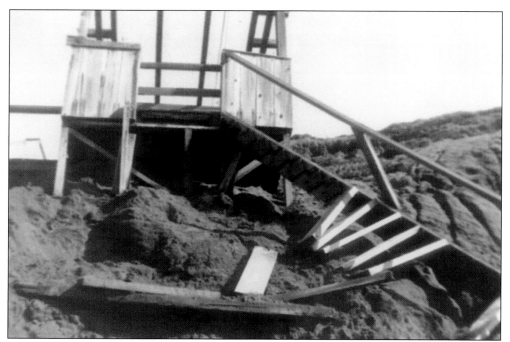

This Sunset Cliffs viewing area and attached staircase also were victims of the 1939 storm. The upper bluffs are uncompacted sandstone and vulnerable to rain and wind erosion, as well as undercutting by wave action.

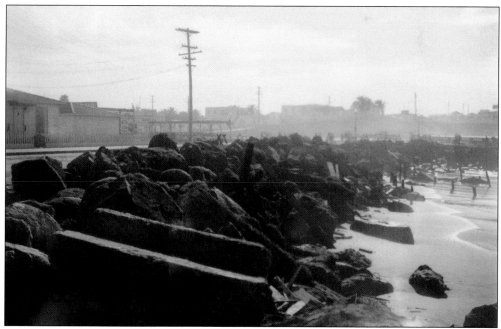

In the mid-1940s, looking south down Abbott Street toward where the flatiron building had been, huge boulders used as riprap were mostly what one saw. Today, beach replenishment programs have reclaimed much of this area, and most of the unsightly boulders have been removed.

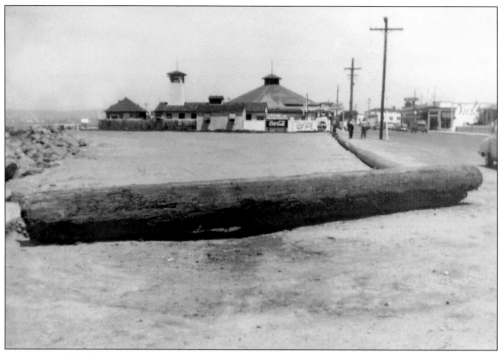

The logs in the foreground outline where the flatiron building, demolished in 1941, once stood.

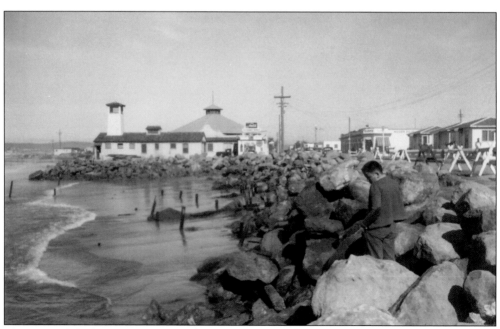

This view of the beach shows the rock barrier that was erected after the destructive 1939 storm to protect the lifeguard station and other buildings along Abbott Street from high surf.

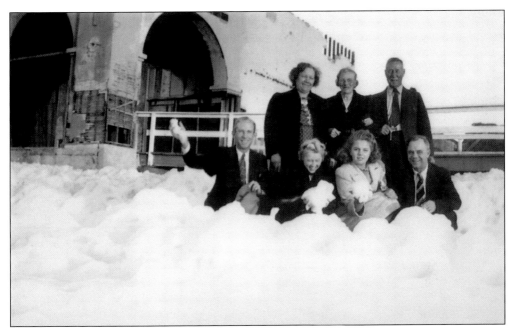

Between major storms in 1939 and 1940, Ocean Beach got a white Christmas when an avalanche of foam came sweeping in on the tide. On Christmas Day 1940, foam several feet high rolled onto Ocean Beach's shores, much to the surprise and delight of the locals. It turned Ocean Beach into what looked like a winter wonderland, with drifts up to 10 feet high. At the time, it was said to be a natural occurrence, but not much explanation was given. Locals saw it as a great photo op.

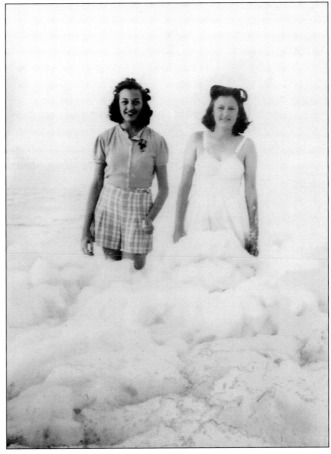

On Christmas Day 1940, these two young women took their holiday picture in the sea foam.

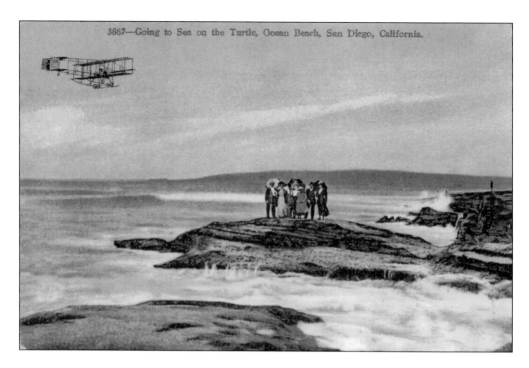

Apparently, Ocean Beach was not only a great place to live, but also a great place to fly over. In the c. 1915 postcard above, a biplane dips precariously close to a group of people gathered on a rock formation called "The Turtle." Below, a World War II–era dirigible gets a good view of the Sunset Cliffs area as it passes over Ocean Beach.

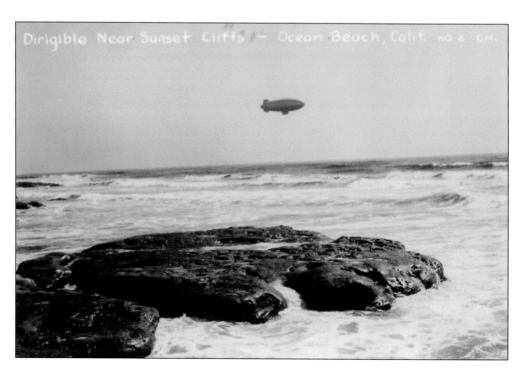

Seven

DID YOU KNOW?

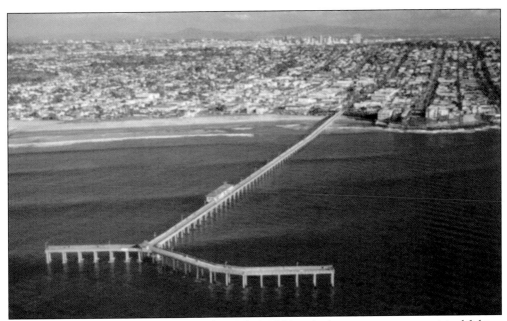

Ocean Beach's Municipal Pier, dedicated on July 2, 1966, is the longest concrete municipal fishing pier on the West Coast. Visitors can come and spend the day on the 1,971-foot-long structure equipped with bathrooms, a restaurant, and even a bait shop for those who want to try their luck with a fishing pole. The pier was built to replace the 1915 fishing bridge that once linked Ocean Beach to Mission Beach and was torn down in 1951.

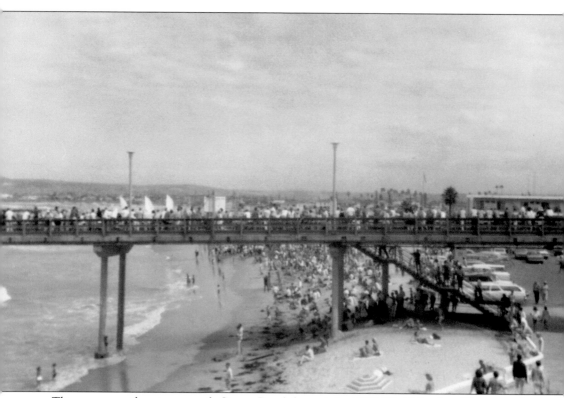

The same year the pier opened, Ocean Beach hosted the 1966 World Surfing Championships, and many spectators found the pier the perfect spot for viewing the competition. Winner of the women's division was Ocean Beach surfer Joyce Hoffman, who subsequently was featured on several magazine covers, including *Sports Illustrated*. Among the male competitors, local surfer Skip Frye was a favorite with the crowd, but he lost out to Australian Nat Young.

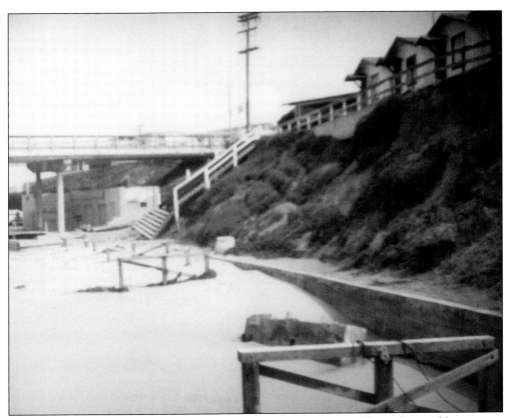

In the 1980s, Ocean Beach's old wood plank boardwalk, which had been damaged by a storm, was replaced by a new concrete boardwalk and seawall. The walkway, which runs from the Silver Spray Apartments north to the end of the pier parking lot, is a heavily used thoroughfare along the beach. The houses at top right are the original Camp Holiday bungalows, built in 1923. The pre-pier photograph below shows a stretch of the earlier boardwalk with its white rail fencing.

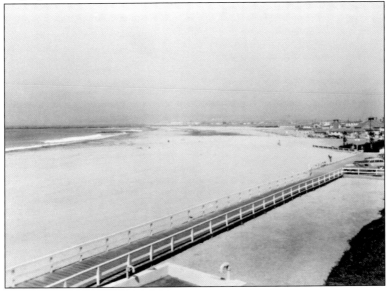

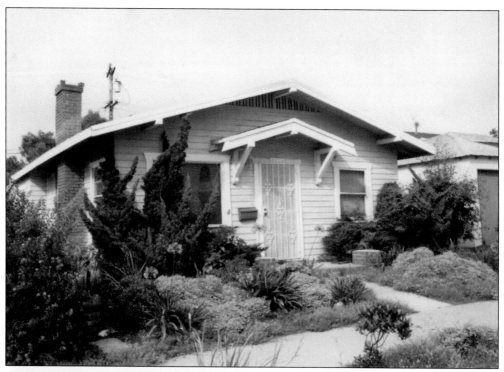

Ocean Beach cottages like these have been preserved thanks to the efforts of Priscilla McCoy, longtime Ocean Beach Historical Society board member. In the late 1990s, Priscilla led a movement to identify cottages in Ocean Beach that had been built between 1887 and 1931 and still retained their original exteriors. She then persuaded owners to participate in what became known as the Ocean Beach Cottage Emerging Historical District. She and Sally West prepared the necessary paperwork to present to the San Diego Historical Resources Board and subsequently, in October 2000, gained the board's approval for the district, which contains 72 individual homes exemplifying Ocean Beach's historical development.

This wave motor once operated below the cliffs at Santa Cruz Avenue. The device was invented by Alexander Jones, who believed the ocean could be harnessed to supply energy for Ocean Beach. The car above was attached by cable to a generator, and the power of incoming waves moved it up and down an incline to produce electrical power, but not very much. The project was soon abandoned, and the innovative machinery quickly became a photo prop, used here by three members of the Turley family.

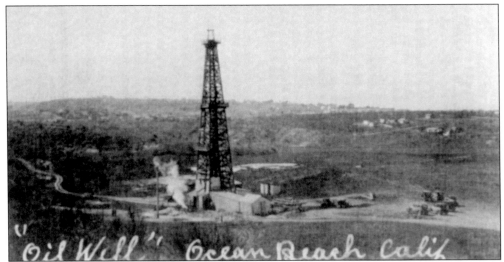

Could there be oil in Ocean Beach? There were no gushers here, but at least three attempts were made to locate "black gold" in the beach area, the earliest taking place when Billy Carlson financed an effort to drill for oil on Pescadero Avenue in 1895. Carlson gave up after 1,200 feet. Then, in the 1920s, John P. Mills attempted to find oil on Sunset Cliffs, but with no luck there either. The final unsuccessful attempt came in 1929, when Borderland Oil Company drilled to a depth of 4,200 feet in Loma Palisades but got nothing. It was kind of like pouring money down a hole.

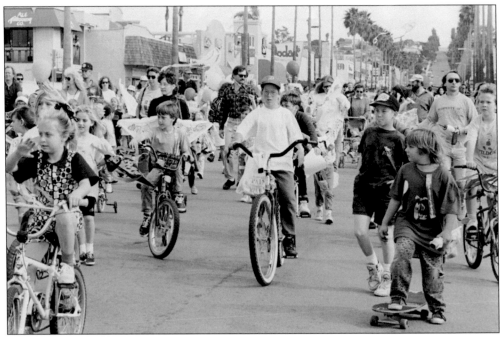

The oldest children's kite festival in the United States got its start in 1948 in Ocean Beach as a 20th anniversary project of the Ocean Beach Kiwanis Club. The one-day festival, still held each year in March, is a free event in which children learn how to make and fly kites. It has expanded in recent years to include a street fair with food, crafts, music, and carnival rides. (Courtesy of Steve Rowell.)

114

Some of the world's largest Torrey Pines can be found on Saratoga Avenue in Ocean Beach. Torrey pines are only native to two places: San Diego and Santa Rosa Island, off the coast of Santa Barbara. In the 1930s, a local WPA beautification project was to plant Torrey Pines along the roadway leading up to Cabrillo National Monument. Pine nuts were gathered from Torrey Pines State Park and grown into seedlings at the Saratoga Avenue nursery of San Diego County employee David Robert Cobb. Irregular watering and hungry critters doomed the highway project, but the trees on Saratoga Avenue thrived and are still there to admire today, thanks to Cobb's wife. She had suggested that he plant Torrey pines on Saratoga Avenue above Sunset Cliffs Boulevard because that stretch of street had no landscaping.

In 1915, the Door of Hope, a home for unwed mothers, was built on a 10-acre site in Ocean Beach's Collier Park. Initially operated by the San Diego Rescue Mission, it was taken over by the Salvation Army in 1931. In 1962, the Door of Hope moved to a much larger facility in Kearny Mesa.

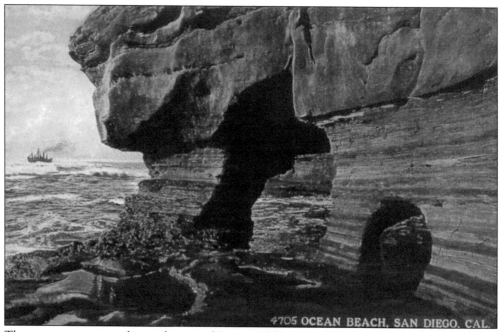

The picturesque sea arches and caves of Sunset Cliffs Natural Park are some 60 to 70 million years old. The collision of two tectonic plates (North American and Pacific) caused this ancient seabed of erosion-resistant but fractured sandstone to rise up out of the ocean.

Carlson and Higgins were not the first developers to file a subdivision map in the Ocean Beach area. That honor goes to J.M. DePuy, who in 1885 filed a map (pictured) for an area known simply as DePuy's Subdivision. (Ocean Beach had not been named yet.) Except for Aliso Street (now Valeta) and Alvarado Street (now Greene), these street names in the northern part of the community remain the same today. Unfortunately, things did not go well for DePuy, and he abandoned his business venture early. (Courtesy of County of San Diego.)

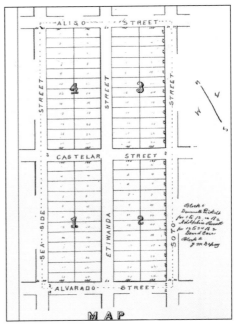

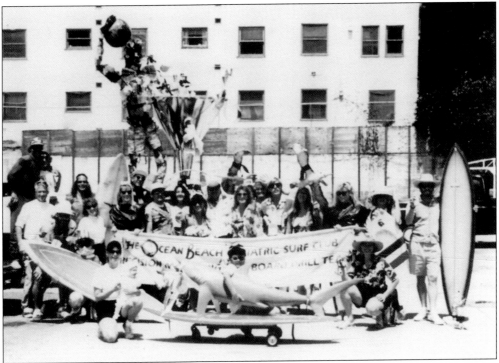

The 1984 Ocean Beach Christmas Parade featured a new marching group with the longest name of any entrant ever. The Ocean Beach Geriatric Surf Club Precision Marching Surfboard Drill Team and Gidget Patrol received loud applause and went on to entertain crowds at countless parades and performances around the country and also appeared in Hollywood videos, movies, and television commercials. The only rules to be in the club were: "You must surf, you must be over 30, and you can't be trusted."

The Ocean Beach 100% Club
ANNOUNCES THE

OCEAN BEACH

Let Joy, Mirth and Frivolity Reign Supreme on Opening Day at Ocean Beach	Official Opening Day Sunday, May 25, 1924	Let the Rest of the World Go By and Come to Ocean Beach Sunday Queen of All the Beaches

FREE - - FREE - - FREE
THE BIGGEST, BEST DAY OF THE MONTH
EXTRA SPECIAL ATTRACTIONS

DUKE KAHANAMOKA
CHAMPION SURF BOARD RIDER OF THE WORLD

Will Present His Aquatic Exhibition Riding the Surf at 3:30 P. M. Sharp

FLIRTING WITH DEATH

Daredevil Martin Jensen, Aviator

DINE AT ONE OF THE MANY FINE OCEAN BEACH CAFES	Gravity Defying Stunts ASSISTED BY VAN A. LANE CHAMPION WING WALKER	AMPLE AUTO PARKING SPACE

All Staged Over the Ocean Beach Surf Line

Skate at the Skating Rink Swim in Silver Spray Plunge
Dance in the Dance Pavilion - - - - - Ride in the Giant Ferris Wheel
Ride On The Latest Improved Merry-Go-Round
The Joy Zone Welcomes You With Many New Concessions and Attractions

MAKE SUNDAY OCEAN BEACH DAY
GET THE HABIT

20-MINUTE CAR SERVICE USE YOUR PASS

In 1924, Hawaiian Duke Kahanamoku (whose last name is misspelled on this poster) came to Ocean Beach to give a surfing exhibition. The appearance by the champion surfer and Olympic gold medalist in swimming was one of the events scheduled for the official opening day of the summer season. After drying off, Duke attended the Hawaiian Nights Fete at the Benbough dance pavilion, where he was guest of honor. According to Ruth Held's *Beach Town*, Kahanamoku had first visited Ocean Beach in 1916, at which time he "gave a notable exhibition on a wide wooden board, standing up and riding the waves in to shore." Other early demonstrators of this now popular California sport were members of the Hawaiian Village compound at the 1915–1916 Panama-California Exposition in Balboa Park. Having been stationed at the exhibit so long that they had become rusty at their sport, the Hawaiians traveled across the bay to ride the surf off Coronado's Tent City.

This six-foot bronze statue on the beach at Abbott Street and Santa Monica Avenue was installed in May 2013 as a tribute to Ocean Beach's lifeguards. A nearby plaque recalls a 1918 tragedy in which 13 swimmers drowned at Ocean Beach when caught in a strong rip current. The four lifeguards on duty that day averted an even greater tragedy by rescuing, with the help of several civilians, 60 others who were struggling in the undertow. (Courtesy of Steve Rowell.)

The Christmas season does not begin in Ocean Beach until the tree goes up at the foot of Newport Avenue. This tradition started in 1980 when Rich James, his brothers, and a few friends made a gift to the community of a tree brought down from Mount Shasta. The tradition continues with an Ocean Beach resident or group donating the tree each year, sometimes coming from a person's own yard. Students from Ocean Beach Elementary (along with Santa) do the decorating. The first community Christmas tree in 1980 inspired the citizens of Ocean Beach to put together a makeshift kazoo band (below) and start another tradition—the Ocean Beach Christmas Parade, still going strong three decades later.

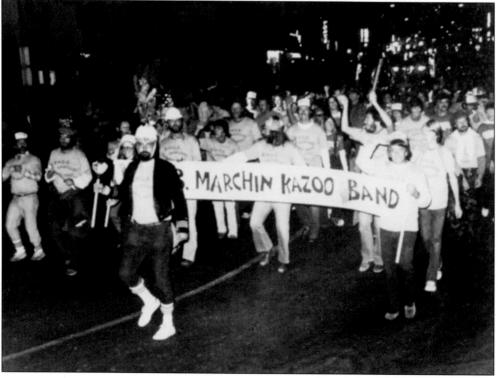

Ocean Beach little leaguer David Wells (left) grew up to be a big leaguer with the New York Yankees. On May 17, 1998, the Point Loma High grad pitched a perfect game against the Minnesota Twins in Yankee Stadium. Surprisingly, he was not the only kid from Ocean Beach to pitch a perfect game in a Yankee uniform in Yankee Stadium. Don Larsen (right), another Point Loma High grad playing for the Yankees, not only pitched a perfect game 42 years earlier, but he did it during the 1956 World Series. A mathematician computed the odds of two pitchers from the same high school pitching perfect games for the same team in the same stadium: 96 billion to 1!

Ocean Beach has several flocks of beautiful wild parrots, mostly of the Amazon Green and Mexican Red-Headed varieties. How the birds came to Ocean Beach is something of a mystery. One story has it that several birds were released when a house caught on fire, and they multiplied in the wild. The parrots are not shy about making their presence known. Just two parrots can make enough noise to cause conversations to stop. (Courtesy of Steve Rowell.)

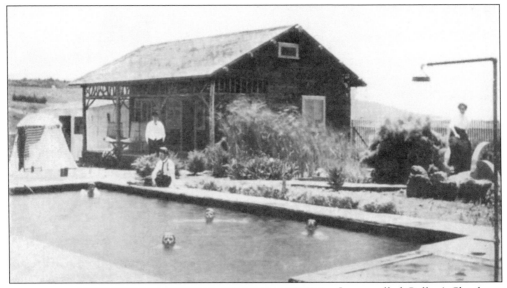

It was called Collier's Shack, but in the early 1900s, D.C. Collier's home in Ocean Beach was a spacious modern dwelling with many innovative features, including a "cement plunge" (swimming pool), possibly the first in San Diego. The original house that Collier built in 1887 was a two-room bungalow, but he kept expanding it, adding a sun porch here and a bedroom there, until eventually it could sleep 16 people.

After Wonderland, Ocean Beach's amusement park, went out of business, two buildings that had served as the park's offices were moved to the corner of Lotus and Abbott Streets, where they were placed side by side and remodeled into an apartment building. There are still apartments at this site, but due to renovations and additions over the years, it is difficult to spot the old buildings.

One of Ocean Beach's most memorable characters was artist Clint Cary (1909–1993), also known as "The Spaceman of Ocean Beach" (left). Clint gained this nickname after having claimed that he had twice traveled with extraterrestrials to the planet Rillispore in the galaxy of Rigel. Inspired by these journeys into outer space, Clint began creating colorful pieces of cosmic art, which today are valuable collectibles. He also began passing out "Spaceman Cards," each with a number that represented the recipient's place in line for the next spaceship to Rillispore. Cary had a plan: When the world came to an end, two spaceships would arrive from Rillispore to transport the chosen ones to their new distant-planet home. Seated on the right is jazz musician Bob Oaks, another legendary character of Ocean Beach, who was a close friend of Clint Cary and a promoter of his art. Oaks lived in one of the cottages above the Ocean Beach pier, where for years he hosted Sunday night jam sessions featuring out-of-town jazz musicians. (Courtesy of Steve Rowell.)

Ocean Beach has held many a protest, especially since the arrival in the 1960s–1970s of many young activists, who eventually had a great influence on the group thinking of the beach community. In this c. 1970 photograph, Ocean Beach residents are picketing the local Bank of America because they saw it as a large corporation that was benefiting from the Vietnam War through its ties to the defense industry. Speaking out for what is right for the world in general—and Ocean Beach in particular—is an idea that goes back many years. For example, in 1922, Ocean Beach sought a divorce from San Diego, citing as grounds the slow response of the city in repairing damages caused by heavy rains at the beach. Community leaders said that the City of San Diego was ill equipped to oversee a summer beach resort, likening it to Los Angeles trying to run Long Beach. However, the idea did not get enough backing to be placed on the ballot, and Ocean Beach remained a part of the city.

American artist Mike Dormer of Ocean Beach gained fame in the surfing world with his creation of "Hot Curl," a six-foot-tall, 400-pound concrete statue that was installed at Windansea Beach in La Jolla, a mecca for local surfers. The goofy-looking surfer representation, which became widely famous, now resides in the California Surf Museum in Oceanside.

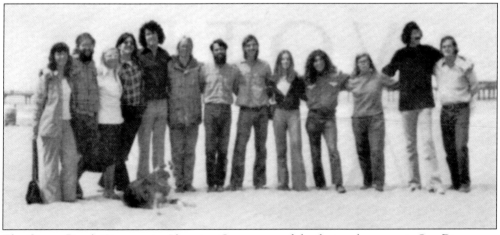

The Ocean Beach Community Planning Group, one of the first such groups in San Diego, was formed in the spring of 1976 by 14 activists. From left to right are members Maryann Zounes, Jerry Hildwine, Dolores Frank, Frank Gormlie, Lars Tollefson, Chris Bystrom, El Riel, Tom Kozden, Judy Czujko, Rich Cornish, Jill Mitchell, Doug Card, and Phil Elsbree (Norma Fragozo is not pictured). This group developed the first Precise Plan for Ocean Beach, which served as a blueprint for land use for over 30 years.

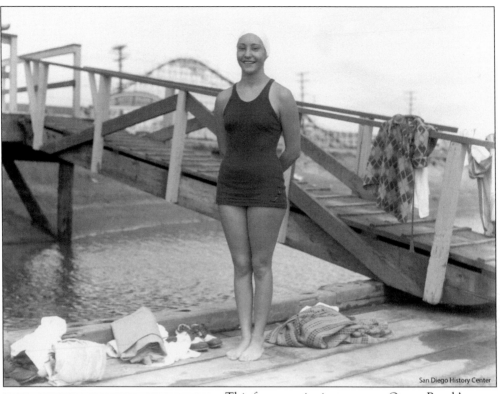

San Diego History Center

This former swim instructor at Ocean Beach's Silver Spray Plunge made newspaper headlines in 1950 when she broke the women's record for swimming the 23-mile English Channel set in 1926 by Gertrude Ederle. Florence Chadwick (1918–1995), the daughter of Ocean Beach policeman Richard Chadwick, broke many other long-distance swimming records, including some set by men, and was the first woman to swim the channel twice (both directions). In 1984, she was inducted into the San Diego Hall of Champions as the greatest long-distance swimmer in history. After retiring from competitive swimming, she worked as a stockbroker in San Diego and was vice president for First Wall Street Corporation. (Courtesy of San Diego History Center.)

Faye Baird, a 1927 graduate of Point Loma High School, was one of California's first women surfers. As a teenager, she learned to surf from Charlie Wright (left), a local disciple of Duke Kahanamoku. She first rode tandem with Charlie, but within a matter of days was riding a board on her own, thus earning her place in history as the first woman surfer in San Diego.

The entryway sign for Ocean Beach was first installed in 1984. When it needed to be replaced in 2012 due to wear and tear, the community was presented with multiple ideas for a new sign. But all of these suggestions were shot down, as OBceans overwhelmingly voted for an exact replica of the old sign, showing that some things just should not be tampered with.

DISCOVER THOUSANDS OF LOCAL HISTORY BOOKS FEATURING MILLIONS OF VINTAGE IMAGES

Arcadia Publishing, the leading local history publisher in the United States, is committed to making history accessible and meaningful through publishing books that celebrate and preserve the heritage of America's people and places.

Find more books like this at
www.arcadiapublishing.com

Search for your hometown history, your old stomping grounds, and even your favorite sports team.